Gettysburg to Vicksburg

Shades of Blue and Gray Series

EDITED BY HERMAN HATTAWAY AND JON L. WAKELYN

The Shades of Blue and Gray Series will offer Civil War studies for the modern reader—Civil War buff and scholar alike. Military history today addresses the relationship between society and warfare. Thus biographies and thematic studies that deal with civilians, soldiers, and political leaders are increasingly important to a larger public. This series will include books that will appeal to Civil War Roundtable groups, individuals, libraries, and academics with a special interest in this era of American history.

Gettysburg to Vicksburg

THE FIVE ORIGINAL CIVIL WAR BATTLEFIELD PARKS

Photographs by A. J. Meek *Text by Herman Hattaway*

Herman Hattaway

University of Missouri Press Columbia and London

Copyright © 2001 by
The Curators of the University of Missouri
University of Missouri Press, Columbia, Missouri 65201
Printed and bound in Korea
All rights reserved

5 4 3 2 1 05 04 03 02 01

∞™ This paper meets the requirements of the
American National Standard for Permanence of Paper
for Printed Library Materials, z39.48, 1984.

Design and Composition: Kristie Lee
Printing and Binding: Pacifica Communications
Typeface: Minion

Library of Congress Cataloging-in-Publication Data

Meek, A. J.
 Gettysburg to Vicksburg: the five original Civil War battlefield parks /
photographs by A. J. Meek; text by Herman Hattaway.
 p. cm.
 Includes index.
 ISBN 0-8262-1321-9 (alk. paper)
 1. United States—History—Civil War, 1861-1865—Battlefields— Pic-
torial works. 2. Shiloh National Military Park (Tenn.)—Pictorial works.
3. Antietam National Battlefield (Md.)—Pictorial works. 4. Gettysburg
National Military Park (Pa.)—Pictorial works. 5. Vicksburg National
Military Park (Miss.)—Pictorial works. 6. Chickamauga and Chattanooga
National Military Park (Ga. and Tenn.)—Pictorial works. 7. United
States—History—Civil War, 1861-1865—Campaigns—Pictorial works.
I. Hattaway, Herman. II. title.

E468.7 .M53 2001
973.7'3—dc21 2001018918

To the men and women of the National Park Service, many of them our friends and all justly noted for their helpfulness to park visitors on countless occasions

CONTENTS

PREFACE

THIS BOOK IS primarily a study of battlefield parks; but the parks commemorate battles, so, inescapably, this book is secondarily about battles. We believe that the parks are sacred places and that learning, on a number of levels, can be achieved by thoughtful visits to them. The photographs of each park are arranged roughly as a visitor might encounter the scenes they depict. We have arranged the sections in the order that they were first "set aside" as preserved battle sites to visit. Thus, this means not in the order in which they were designated as "national military parks."

We were careful in our selection of parks and were *not* initially guided by the fact that those we ultimately chose to include coincidentally happened to be the first five in the National Military Park system, which today has twenty-eight Civil War battle sites within its structure. At first, we were going to cover only four parks: Shiloh, Antietam, Gettysburg, and Vicksburg. Gettysburg is the most well known and most visited park and is regarded by many folk as where occurred the Civil War's "great turning point." Shiloh was the first big battle in the West—and we believe that the West is too often neglected by students of the Civil War, and indeed that the war's outcome was decided in that theater. Antietam marks the single bloodiest day in American military history. Vicksburg is not heralded fairly, as we believe it was, in truth, U. S. Grant's greatest strategic accomplishment; and, while it is much visited, it, nonetheless, is too much ignored by too many students of the war.

Upon realizing that we had four of the first five National Battlefield Parks, we were induced to add the fifth (which actually was the first!): Chickamauga-Chattanooga. As it hap-

pened, there were commemorative efforts at our four initial selections that predated the creation of the National Military Park system. The national cemeteries alone would have hallowed those locations, but those sites were of such significance and importance that many individuals were early induced to work toward establishing some special displays, memorials, and preserved locations of reverence.

Between 1890 and 1899 the Congress of the United States was induced to authorize the establishment of the earliest national military parks. The 1890s marked a new phase in remembrance and reverence for what had happened in the Civil War. The people were becoming harmonious at the same time that a great surge of national pride and exuberant interest in new and noncontigual expansion was but one of many reasons that Americans now wanted to feel good about the whole of their country. Further, it was increasingly obvious not only that reverential commemoration of the battle sites of the Civil War might be popular, but also that the sites offered opportunity for the professional military to study the lessons of warfare and even to train.

Chickamauga-Chattanooga became the first one, perhaps for any number of interrelated factors. First of all, there were two influential veterans of the struggles there—Brig. Gen. Henry V. Boynton and Brig. Gen. Ferdinand Van Derveer, both veterans of the Army of the Cumberland—(indeed Van Derveer's brigade had been among the first to scale the heights of Missionary Ridge)— who, during a visit to the area in 1888, conceived the idea for a national park and took the lead in pushing for it.

There were already extant a goodly number of veteran's societies. One of them, the Society of the Army of the Cumberland, worked with another organization, the Chickamauga Memorial Association, to generate support for the idea of a military park. Boynton and Van Derveer spent nearly two years promoting the idea among both Union and Confederate veterans. The battle area offered the double appeal of commemorating spectacular military victories by both sides: Chickamauga, one of the most stellar of the Confederate achievements, and Chattanooga-Missionary Ridge, a stunning blow in behalf of the Union.

Early in 1890, Ohio Congressman Charles H. Grosvenor, with Boynton's urging, introduced into the Fifty-first Congress a bill drafted by Boynton that would establish the Chickamauga and Chattanooga National Military Park. The House and Senate Military Affairs Committees reported favorably on the proposal, and Congress passed the bill. President Benjamin Harrison signed it on August 19, 1890.

As the first and largest of the five National Military Parks

that would be created within the span of just a few years, Chickamauga-Chattanooga became the prototype for subsequent national military and historical parks. All of the parks were under the supervision of the War Department until they were transferred to the National Park Service in 1933.

The Missionary Ridge section of Chickamauga-Chattanooga is by far the most disappointing commemorative site, owing to encroaching urbanization, resulting in failure to preserve any coherent chunk of terrain that would be illustrative of what soldiers faced in the Civil War battle, and there is no visitor center dedicated to it.

All of the sites we treat herein, where occurred incidents of hugely heroic struggle and sacrifice, are marvelous treasures. But time, erosion, and encroachment all have taken dreadful tolls. If Missionary Ridge is a quintessential example, all of the parks—in varying degree—are much in need of restoration, refurbishment, and safeguarding so that they will remain for future generations the troves of inspiration and dramatic impact that they are now and have been. (Ironically, Chickamauga—so near Missionary Ridge—may be the most safely secure of those we herein treat. The sanctity of Chickamauga battlefield is being enhanced by the construction of a bypass highway that will reroute spurious vehicular traffic and allow for reducing the number of speed bumps within the park.) Readers who are interested in knowing more about the general situation of the parks and what can be done to help alleviate or improve conditions should see the excellent book by Dwight F. Rettie, *Our National Park System: Caring for America's Greatest Natural and Historic Treasures* (Urbana: University of Illinois Press, 1995).

ACKNOWLEDGMENTS

BOTH MEEK AND HATTAWAY extend their thanks to David Madden, founding director of the United States Civil War Center, located on the campus of Louisiana State University in Baton Rouge. He has been both an advisor and a friend.

Meek thanks his daughter, Patricia, and his wife, Belinda, for accompanying him on so many tiring but fulfilling trips to Civil War battlefields. Meek also wishes to express thanks to Beverly Jarrett, director of the University of Missouri Press, whose vision for this project was clear when those of others were not, and to Sara Davis, editor, whose patient and quiet disposition calmed many emotional storms in bringing this book to fruition.

Hattaway expresses warm esteem to Edwin Cole Bearss, retired chief historian of the National Park Service, author, tour guide extraordinaire, and longtime friend. Hattaway especially profited from Bearss's putting him in touch with various personnel at the several parks who made available internally produced adminstrative histories.

PHOTOGRAPHER'S COMMENTS

MY INITIAL INTEREST in the Civil War was prompted by two events: first, an invitation from David Madden, a novelist and former director of the United States Civil War Center, to join the center's board of advisors; second, a report that aired on public radio, which described the tenuous plight of our nation's Civil War battle-fields. It explained that they are in grave danger, and some may be lost through the neglect and indifference of a large segment of the populace and of governmental officials. Encroachment by parking lots and shopping malls are an increasing threat, both real and aesthetic, to these sacred grounds.

There have been many debates in photography circles over the choice of materials used to express one's work. At the center of the debate has been the use of color versus black and white. My previous book projects have been in color because of the seasons of the natural landscape. On this project I chose to work in black and white because it seemed more suited to the seriousness of the subject. My decision to split tone the photographs defines the space, giving it a greater dimension and a mellow, almost somber, mood to the work. These photographs represent a tribute and a fitting memorial to the men who died and the events that took place on those grounds.

I began work in the summer of 1993 on Lookout Mountain in Chattanooga. That early attempt was not encouraging. A traveling photographer using sheet film must turn motel bathrooms into makeshift darkrooms. Film must be loaded at night because changing bags are not large enough for eight-by-twenty–inch film holders, and they are often dust collectors besides. The room must be made light-tight, which requires putting black masking tape over the cracks between

the sides of the door and the frame and stuffing a dark cloth between the bottom of the door and the floor. All lights and the TV must be turned off. The photographer has to wrap a towel around his head to prevent perspiration from dripping on to the film. It is often a hot, stuffy, and tedious job. The first time I tried it, water from the tub's spigot dripped into my exposed film box, making my early negatives almost unusable.

I continued my work during June 1994 with the help of a summer stipend from Louisiana State University's council on research. My project that summer was to photograph the battlefields in Virginia, Maryland, and Pennsylvania. In addition to the eight-by-twenty banquet camera, I brought my four-by-five wooden field camera.

Overcast conditions are best when shooting wooded areas; bright sunlight will create confusing patchy patterns of light and dark in the photos. Clear, sunny days are good for open areas or specific subject matter, such as the many monuments that commemorate the war. In this regard, I was extremely lucky to be at the sites on days offering the right kind of light for the subjects and landscape I was photographing.

A battlefield has its own spirit. It is a living thing. Each park left me with an impression of its distinct personality. Gettysburg in July is packed with visitors. During my visit, tour buses arrived regularly from Washington, D.C. Curious onlookers, interested in the same scene I was trying to capture, would fill my viewfinder, and there was nothing to do but wait until they moved out of the frame.

There is a major reenactment of the battle every July 4, complete with cannon fusillades and infantry and cavalry charges. Just underneath the surface of the confusion and turmoil caused by visitors and preparations for the re-creation of the battle is the feeling of a victorious but ghostly energy.

The day I photographed the Antietam battlefield, the sky was gray and the mood foreboding. The thunder of an approaching storm sounded like distant field artillery. It rained shortly after I left. Antietam remains the saddest place I have ever photographed. More men were lost there in a single day than in any other battle in the war, and the place is pervaded by a sense of tragedy. I felt it each time I visited the park.

Because Vicksburg Military Park is close to my home in Baton Rouge, I visited it more often than other sites. I felt the most peaceful sense of healing there among its high bluffs, rolling hills, and river views. Joggers run through the park at dusk, and women push baby carriages along its monument-lined avenues.

The fighting at Lookout Mountain in Chattanooga has been called "the battle in the clouds." Nearby Chickamauga also

seems peaceful with its open, uncluttered space and amiable southern light. It is difficult to imagine that war once came to the gentle rolling hills and piney woods. The pyramid-shaped cannonball monuments are a hallmark of the park.

Shiloh has a *gris gris* (bad luck) for me. It is the most isolated of the parks, yet it has many visitors. The first time I went there, my wife, Belinda, accompanied me. It rained buckets. Belinda had a sick headache. I had misread my light meter, and I overexposed my film by ten f-stops. What should have been a one-second exposure became a one-minute exposure. I had to refer to my technical books for the proportions of a strong bleaching compound that would reduce the silver in the negative enough to render it printable. Another time would be no different, but it was my emotional state of mind that was in doubt. After five years my project was coming to a close.

What emerges from the work in these pages is an awareness of how visually rich and historically important these places of sacred beauty are for our nation. No longer can we hear the terrible noise of battle—men's cries amid exploding shells. Gone also is the destruction of war—the torn earth, the broken trees, the smell of death and black powder. Trees and grass have serenely covered the hills and rills of breastworks and gun emplacements. Yet, the feelings of profound sacrifice and strife remain. I hope that I have brought something to both the generations that were destroyed by the war and those that will follow our own in the form of photographic preservation, the awareness of history, and a sense of God's healing mercy.

A. J. Meek

I

Gettysburg

I

Gettysburg

GETTYSBURG is far and away the best known of all the Civil War battles—and the site itself is the most visited of the commemorative areas; about a million and a half persons visit there each year. Many students regard Gettysburg as *the* turning point of the war. It is worth noting, though, that this battle occurred at very near the *middle* of the conflict. While it was a decisive Union victory to be sure, it certainly was *not* the "beginning of the end."

Many students of the war have been led astray as to the Confederate high command's main motive for undertaking the campaign by an incorrect and unsubstantiated claim made by Confederate Postmaster General John H. Reagan in his memoirs, which were published in 1905. Reagan asserted that the Gettysburg campaign was meant to be a distracting coun-teroffensive, alleviating the dismal Confederate situation in the western theater (where Vicksburg was under siege and destined to fall on July 4, 1863).

In truth, Gen. Robert E. Lee much earlier had contemplated something like the Gettysburg campaign. In the summer of 1863, the Confederates having scored two major victories within the past five months, Southern morale and optimism were high, and Lee at last felt ready. His true motives for the Gettysburg campaign were these: he wanted to stymie any Federal plan for a summer campaign in Virginia; he hoped to crush the Federal troops then occupying the lower end of the Shenandoah Valley; and—similar to the situation in September 1862, when he had invaded Maryland—he wished to give the people of Virginia a respite from nearness to the war as

well as the chance to produce a good crop; and above all, he wanted to spend the summer maneuvering and absorbing supplies taken from the enemy in lower Pennsylvania.

On June 3, 1863, the advance elements of the Confederate army pulled out of positions near Fredericksburg, Virginia, where they had been encamped since the Battle of Fredericksburg the previous December. More units quickly followed, and soon there was only a token force left to deceive the Union army. The Federal force, under Maj. Gen. Joseph Hooker, responded soon enough: rumors abounded that the Confederates were on the move, and to check them out, Hooker ordered cavalry reconnaissances. His men encountered and engaged the enemy in battle at Franklin's Crossing on June 5 and at Brandy Station on June 9.

The Battle of Brandy Station was of considerable symbolic importance. It was a classic cavalry fight: bugles sounding, sabers flashing, revolvers discharging, dust and smoke and confusion everywhere, and the outcome long in doubt. Both sides fought with great determination and skill. But there was no outcome, really. By late afternoon, both sides had had enough, and the Federals withdrew. An unusually large number of the wounds sustained were caused by sabers, more than in any other battle of the war. But the significance was this: theretofore Federal cavalry had been commonly regarded as notoriously inferior to the Confederate horse soldiers, and their performance here matched that of the Southerners, signifying that the Yankee cavalry had come of age.

The next day Hooker pieced together his bits of data and concluded that he had an enticing opportunity now to attack the Confederate capital of Richmond. President Abraham Lincoln, however, responded immediately in the negative: "I think *Lee's Army* and not *Richmond,* is your true objective point. . . . Fight him when opportunity offers. If he stays were he is, fret him and fret him." But Hooker continued to seem befuddled and did not take action. Late in the afternoon on June 14, the president wired Hooker, "If the head of Lee's army is at Martinsburg and the tail of it on the Plank road between Fredericksburg and Chancellorsville, the animal must be very slim somewhere. Could you not break him?" But Hooker did not "break him," nor did he try; and on the next day, June 15, 1863, Lee's advance units began forcing their way across the Potomac River.

Long marches each day in high heat took a toll, but on June 18 a cold front brought heavy rains, cooler temperatures, and even some sleet. Some Confederate elements encountered resistance, and a few clashes occurred, but Lee got his army easily into Pennsylvania. His men then commenced a lavish gathering of all manner of goods and also some blacks who

supposedly were escaped slaves (and they were sent South). The northeastern public panicked at Lee's advance, and Lincoln called out 100,000 militia; but in truth the president remained calm, reasoning correctly that Lee was making not an invasion but a raid. In other words: Lee was not trying to take and hold permanently any territory but rather was on a marauding expedition, and further, Lee's army would be vulnerable so far from its base. This presented the Union forces, the president proclaimed, with "the best opportunity we have had since the war began."

But the days of June trickled away, and by his inaction Hooker exhausted the last chits of confidence that Lincoln and general-in-chief Henry W. Halleck might have had in him. On June 24 Hooker asked for orders, saying, except in relation to his own army, "I don't know whether I am standing on my head or feet." On June 27 Hooker was relieved, and one of his corps commanders, Maj. Gen. George G. Meade, was given command of the Army of the Potomac.

Forty-eight years of age, Meade had a hair-trigger temper and a penchant for speaking in the heat of a moment in a quite offensive and abrasive manner, which brought him his revealing nickname: the "damned old goggle-eyed snapping turtle." But he was a solid, honest, and somewhat gifted, though not brilliant, officer. He had seen much combat. He

was a master of logistics, and he had an extraordinary eye for topography. He would prove to be a dull but very capable and steady army commander. Lee astutely rated Meade as more able than Hooker but assessed that the change of command, coming at so critical a moment, would cause difficulty in transition.

Thus, Lee continued the campaign in a mood of blinding exhilaration. He was ill—perhaps gravely so, probably having recently suffered a minor heart attack. And he would be ill-served by his principal subordinates in the battle, much missing the services of Stonewall Jackson, who had died only a few months before at Chancellorsville. Corps commander Richard S. Ewell proved the most inadequate, for he would fail to act—as it near-universally has been assumed that Jackson would have—and expand appropriately upon Lee's loose and unspecific orders. Ewell may have had severe mental problems. His appearance reminded some observers of a bird; legends persist that he sometimes hallucinated that he *was* a bird: for hours at a time he would sit in his tent softly chirping, and at mealtimes he would eat only sunflower seeds or grains of wheat. Ewell's principal subordinate, division commander Jubal A. Early, matched him in lackluster performance at Gettysburg (although, strange to say, Lee believed Early had done well and recommended him for promotion to lieutenant

general). Another officer, more aggressive than Hooker and Early, corps commander Ambrose P. Hill, also bears some blame for inadequate performance at Gettysburg: he was new to corps command, not at ease in it, and also ill—so much so that his conduct has suggested to many twentieth-century students that he had psychosomatic problems. His recent biographer James I. "Bud" Robertson, Jr., has proved that Hill suffered with recurrent malady springing from gonorrhea, which Hill had likely contracted from a prostitute in New York City, whom he managed to visit while he was a cadet at West Point!

The battle occurred, almost by accident, at the insignificant little town of Gettysburg. Most unfortunately for the Confederates, Maj. Gen. J. E. B. Stuart had taken the bulk of the gray army's cavalry on a raid, and this prevented Lee from learning of the Federal army's nearby presence until June 28. A spy came in that night to Lt. Gen. James Longstreet's camp with a rather accurate, and quite surprising, report of enemy troop locations.

Shortly before dawn on July 1, 1863, a chance engagement commenced a couple of miles northwest of Gettysburg. Two brigades of John Buford's Federal cavalry division, scouting ahead of the main Union force, clashed with James J. Pettigrew's Confederate brigade, which was headed for the town, where Pettigrew hoped to take a supply of shoes incorrectly believed to be there (although there *was* a shoe factory in Gettysburg, all the shoes had been snatched by previous raiders). Buford recognized the potential strategic importance of the numerous roadways that crossed at Gettysburg and noted the imposing and militarily significant high ground to the south. Buford's dismounted troopers, armed with Spencer repeating carbines, were able to hold off increasingly strong infantry assaults until Federal infantry reinforcements could join them. The Federal resistance was much stiffened by later in the morning, but the Confederates nevertheless built up superior strength, captured McPherson Ridge, and pushed toward Seminary Ridge. About noon the fighting died down. The Unionists worked at building up their defenses, while the Confederates readied for another attack on Seminary Ridge.

More fighting was soon to erupt. Elements of the Federal Eleventh Corps began arriving around 1:00 P.M. Two of its divisions deployed to extend the north flank while a third occupied Cemetery Hill in general reserve. Ewell's corps then began arriving in force from the north and slammed into the Eleventh Corps positions, driving the corps back and inflicting heavy losses. The Union forces fell back to Cemetery Hill, where they rallied.

General Meade sent Maj. Gen. Winfield Scott Hancock to organize the men on Cemetery Hill and to make observations as to whether this was a good place to allow a full engagement of the two armies—another defensive position already had been reconnoitered farther south, in Maryland, along Big Pipe Creek, and Meade also was willing to consider sidling northward. Hancock directed the extension of the Federal position to Culp's Hill and then, with two other generals, carefully examined the terrain. This *indeed* was the place to fight, he reported to Meade.

By midafternoon the Confederates had swept through and captured Gettysburg. But the beginnings of a Federal occupation of Culp's Hill induced Ewell not to advance any farther, despite Lee's orders to secure the heights below the town "if practicable."

The first day of the battle ended as an apparent Southern victory. The Federals' Eleventh Corps had lost over 4,000 men to capture, and many more stragglers were in considerable disarray. But Lee still did not know with any precision where the enemy forces were located—the absence of Stuart's cavalry was a sore vexation.

Lee ordered his two corps on the field to avoid any general engagement until Longstreet could bring his corps to join the main force. During the night—except for one infantry division and Stuart's cavalry—the whole Confederate army united and strung out in position along Seminary Ridge; meanwhile, the Federal army consolidated and occupied the "fishhook" formed by Culp's Hill, Cemetery Hill, Cemetery Ridge, and the Round Tops.

For the second day of the battle, July 2, 1863, Lee's first inclination was to renew the attack upon the Federal right. But Ewell and Early talked him out of that, stating flatly that they could not take Culp's Hill nor Cemetery Hill either, and recommended instead that Longstreet assault the Round Tops. Longstreet was opposed to attacking at all—wisely, as subsequent events proved—and urged instead that the Confederate army stand on the tactical defensive. But Lee had his blood up, and he overruled Longstreet, ordering a main effort against Meade's south flank. Ewell and A. P. Hill were to make secondary attacks to divert Meade's attention.

Longstreet has had a bad press—especially concerning his conduct on the second day of the Battle of Gettysburg. After the war he was the subject of a character assassination, and many students have been misled. As the faulty story goes, since he did not want to fight at all, he dragged his feet and much delayed the assault, losing valuable time and costing the Confederates a victory. Gaines Foster, in his interesting book *Ghosts of the Confederacy,* suggested, with tongue in cheek, that

postwar "Lost Cause" adulators did a sort of "ghost dance," much like the Indians at Wounded Knee, during which, as the left foot landed, the dancers chanted "overwhelming resources," and when the right foot landed, "Longstreet blew it at Gettysburg." In truth, legitimate circumstances induced Longstreet to delay the assault.

And anyway, when Longstreet's assault finally began at about 4:00 P.M., there still were but few Union troops situated on Little Round Top. This was because Maj. Gen. Dan Sickles—without permission—had moved his men forward, beyond their assigned sector, into what came to be called "Sickles' Salient": the soon-to-be-famous spots, the Peach Orchard, the Wheat Field, and the rock-strewn morass called Devil's Den.

Luckily for Meade, the Federal army's chief engineer, Brig. Gen. Gouverneur K. Warren, seized the initiative at Little Round Top and insisted that troops be rushed to occupy that critical hill. Two Federal brigades, those of Brigadier Generals Stephen H. Weed and Strong Vincent, reached Little Round Top in time to repulse the Confederate onslaught. There were, however, some tense and precarious moments before enough men arrived to turn back the Rebels.

Some of Longstreet's men did push to quite near the summit of Little Round Top. Maj. Gen. John B. Hood's division, which was in the lead, fought furiously. Some five hundred of his men successfully scaled Round Top and then began to cross the saddle that connected to Little Round Top. Personally leading the charge, and in the thick of the fray, Hood—one of the South's bravest and most revered fighting generals—fell, badly wounded. The wound he sustained would cost him the permanent use of his left arm. One of Vincent's regiments, the Twentieth Maine under Col. Joshua Chamberlain, which had been the first to rush into position on the southern side of Little Round Top, withstood several withering assaults and finally resorted to using the bayonet. (Chamberlain was awarded the Medal of Honor for bravery.)

There were several more hours of desperate and vicious fighting, especially in the Devil's Den and even more so in the Wheat Field, with Sickles's Third Corps being driven rearward, though fresh divisions from the Fifth, Sixth, First, and Twelfth Corps rushed in to plug the gaps, and as night fell, the Confederate attacks fizzled. The Federals were quite secure, having numerical superiority and with their left flank well covered. The overall Confederate effort had been poorly coordinated. The diversionary attacks all were ill-timed and too feeble, allowing Meade the opportunity to shift forces to reinforce his threatened left.

During the night, despite Longstreet's vehement objections, Lee decided to assail on the next day the Federal center. What

could have made Lee feel that it was propitious for an assault-wave to advance uphill over a little more than a mile of artillery-swept open ground? How could this eighteen-to-twenty minute rapid walk directly into fierce enemy fire be made, and how could the attackers possibly arrive with enough cohesion and vigor to break a line of determined defenders? Lee had tried the enemy position at both ends and found it too strong, perhaps it was weakest in the center—further, Lee erroneously concluded, probably the Yankees were, by now, much demoralized. And, the plan was not without recent precedent. It had been only four years since Napoleon III, at Solferino, had smashed the Austrian center by commencing with a heavy artillery bombardment and following up with a vigorous frontal assault.

The charge would be led by Major Generals George E. Pickett and James J. Pettigrew. Pickett was one of Longstreet's division commanders, and his own division would make up about one-third of the assault force; Pettigrew would command the wounded Henry Heth's division, which would be the main assault force on the left. The name "Pickett's Charge," first given to it by the Richmond press, is a misnomer. In the bitter aftermath, Pickett, too, came to wish that the attack *had* been named "Longstreet's Assault."

A terrific artillery bombardment preceded the charge. But the shots mostly went long; very few Federal infantrymen were hit. Blue-clad gunners responded to the fire, and for a time there was terrific noise, so loud—it was alleged—that it could be heard 150 miles away. Then Federal artillery chief Brig. Gen. Henry J. Hunt pulled his gunners back to safety, and the Confederates wrongly concluded that they had disabled the Union army's guns. When the Southerners did charge, they met an unexpected and murderous artillery barrage. General Hunt always claimed, perhaps with but scant exaggeration, that had his superiors allowed him, he could have stopped Pickett's Charge with artillery alone.

"General, shall I advance?" Pickett asked Longstreet. So overcome by his feelings that he could not speak, Longstreet simply bowed his head. The lines were dressed, the flags unfurled. At ten minutes past three in the afternoon, 10,500 men moved forward in two main ranks followed by a thinner one of file closers. They walked deliberately, at route step—110 paces per minute. In perfect order and steady advance, they covered a hundred yards with each passing minute.

The Confederates were hit first by long-range artillery, then by salvos of rifle fire, and ultimately by brass Napoleon field cannon firing canister. Major General Pettigrew rode close behind his line. His horse was hit. Dismounting, he sent it back with a wounded man and stayed with his line. Grapeshot

smashed the fingers of his right hand. On and on, he and his men pressed forward. He could see clearly the stone wall on Cemetery Ridge.

After they had crossed nearly one-half of the distance, the Confederates reached a swale, which sheltered them from much of the incoming fire. There they halted and re-dressed their lines. Up to this point, the losses, while far from insignificant, had been by no means crippling or demoralizing. The men would go on.

But the fire got hotter, the losses mounted, the formations mostly were broken. Still, some 5,000 of the attackers got to Cemetery Ridge. There was hand-to-hand fighting with the advanced Federal skirmishers. A small breech opened in the Federal line. Confederate Brig. Gen. Lewis Armistead, his hat stuck on the end of his sword, led the advancing Rebels. A handful of them swarmed over the stone wall. But Federal reinforcements rushed into the melee. There was hand-to-hand fighting, lasting somewhat less than two minutes—later declared to be the most dramatic "hundred seconds of the Confederacy." Armistead was killed. The "high tide of the Confederacy" began to recede. The pitifully crushed and vanquished remnants began making their way back. Relatively little musketry fire hampered them as they went, however, for many Federals stopped shooting—partly out of chivalry,

partly from feeling that there had been quite enough killing, and largely because many Federals were busy rounding up prisoners. Some few of the captives still had spunk. "Every rooster fights best on his own dunghill!" shouted one of them.

The whole thing, from start to climax, had taken only about an hour. Of the 10,500 men who had advanced, 5,675 (54 percent) had been killed or wounded. In the three days of fighting, the Federals lost 23,049 soldiers, and the Confederates lost 28,063.

Ironically, both sides sustained the loss of a woman as a result of the combat. A twenty-year-old Gettysburg resident, Jennie Wade, was struck fatally by a stray bullet while baking bread. At least one of the Confederate combatants was female; dressed in uniform, she may have been the wife of a soldier who had chosen to accompany him to war. She was killed in Pickett's Charge and her secret discovered by the burial detail; she was buried with those who fell beside her on the hill.

"Too bad. . . TOO BAD. . . *OH TOO BAD*," Lee cried out in anguish. "The task was too great," he told the survivors of the assault and admitted that it was all his fault. And it indeed *was* Lee's fault: he had fought his worst battle and lost miserably. But, to President Abraham Lincoln's great disappointment, no concluding mop-up pursuit followed the great battle. Brig. Gen. John D. Imboden's Confederate cavalry

covered the Army of Northern Virginia as it disengaged and limped southward, crossing the Potomac River on July 14 and retreating into Virginia. Ironically, in the meaningless rearguard action at Falling Waters, West Virginia, the gallant Major General Pettigrew—who had gone relatively unscathed all the way forward and back in Pickett's Charge—was mortally wounded.

But it is too easy, and misleading, to think the Civil War's outcome was decided by early July 1863. It was *not* at this point merely a matter of time before the North won. Lee's army was weakened significantly, to be sure; never again would *it* be able to assume the strategic offensive. Vicksburg fell the day after the conclusion of the Battle of Gettysburg; the entire Mississippi River would soon be under Federal control and the South split geographically. But the Confederacy still retained a remarkable degree of viable potency. It proved able to redeploy internally and score a morale-boosting victory just a few months later at Chickamauga. The war went on.

And the Battle of Gettysburg, even to those who participated in it, may not have been nearly the devastating, morale-crushing, turning point that many observers then and ever since have assumed. One of Longstreet's quartermaster officers, Edgeworth Bird, wrote to his wife: "we found the enemy posted in a terribly secure position. Now, I know, we should not have attacked him there on the high hills and mountains, but we did so." (Interested readers will enjoy the remarkable correspondence of these folk in *The Granite Farm Letters,* edited by John Rozier [Athens: University of Georgia Press, 1988].)

There are, of course, *very many* good books about this battle. For a delightful starter, we suggest *The Battle of Gettysburg* by Frank Aretas Haskell, edited by Bruce Catton (Boston: Houghton Mifflin, 1957). Lieutenant Haskell wrote this forty-thousand–word letter to his brother, and it is the most vivid and detailed eyewitness account of Pickett's Charge.

We would also recommend the remarkably good *Carolina Cavalier: The Life and Mind of James Johnston Pettigrew* by Clyde N. Wilson (Athens: University of Georgia Press, 1990).

It was inevitable that there be memorials at Gettysburg. And if the fact of the battle itself had not hallowed the ground (which it *did*), Abraham Lincoln made it a shrine when, on November 19, 1863, he delivered his immortal Gettysburg Address as dedicatory remarks for the National Cemetery. The land for this cemetery was purchased as the result of efforts made by two Gettysburg attorneys: David McConaughy and David Wills. McConaughy himself had purchased land that covered some of the most important locations of the battle.

Parts of Cemetery Hill, Little Round Top, Round Top, Culp's Hill, and several other sites soon were acquired.

To oversee mainly the cemetery management, but also the battleground, in April 1864 was chartered the Gettysburg Battlefield Memorial Association—initially a private club of sorts with McConaughy as its principal activist. This was in harmony with the intent of an act passed by the Pennsylvania legislature on April 30, 1864, phrased thus—"hold and preserve, the battle-grounds of Gettysburg . . . and by such perpetuation, and such memorial structures as a generous and patriotic people may aid to erect, to commemorate the heroic deeds, the struggles, and the triumphs of their brave defenders." McConaughy bought up the key topographic features of the battlefield and held them in trust.

The battlefield was surveyed and mapped under the direction of Maj. Gen. G. K. Warren in 1868 and 1869, with the intent that it later be used for military instruction and for documentation to accompany the *War of the Rebellion: Official Records of the Union and Confederate Armies.*

From this beginning, the park grew rapidly, particularly after 1880, when the main Union veteran's organization, the Grand Army of the Republic, acquired controlling membership of the Gettysburg Battlefield Memorial Association. The Soldiers' National Monument was dedicated on July 1, 1869, with Maj. Gen. George G. Meade as the principal speaker. The cemetery was transferred to federal ownership on May 1, 1872. The first monuments on the battlefield were erected in 1878 and 1879. In the summer of 1878, the Grand Army of the Republic held a reunion encampment on East Cemetery Hill. While at the battlefield, the group erected a marble table on Little Round Top to mark the spot where Gen. Strong Vincent had been mortally wounded. This was the first monument on the battlefield to be located outside the cemetery. The following summer, the Second Massachusetts Infantry placed a bronze and granite monument near Spangler's Spring. And this was the first regimental monument to be placed on the battlefield.

The Grand Army of the Republic had a huge membership nationwide, with a great deal of both monetary and political clout. As a result of the enthusiasm of large numbers of the members, in the 1880s particularly, there was generated much impetus to further development of the battlefield. A flood of Union monuments and plaques began to appear on the battlefield: stone towers, magnificent marble shafts, carved and etched monuments of every description. In 1887 the organization purchased the house that Meade had used as his head-

quarters during the battle. The group also directed that only bronze or granite monuments and memorials would be permitted in the future and that monuments should be placed in the spots regiments had held in the lines of battle. While the "line of battle" rule generally would continue to be adhered to, the Seventy-second Pennsylvania won a lawsuit in 1891 and, thus, was allowed to erect a monument at the "advanced" position of the troops.

On February 11, 1895, the park passed into the hands of the War Department and became part of the National Military Park system. At that time there were some seventeen miles of battlefield roads and uncounted miles of defensive works and low stone walls, many of them actually remnants of the battle itself. More park roads were laid, and others were improved, and soon driving tours began. Already efforts were being made to standardize and render accurate the various narrative memorial plaques for every major Federal and Confederate unit engaged in the battle.

Some northern states, like Pennsylvania and New York, already had erected huge shrines to their soldiers who had participated in the struggle. The Pennsylvania Memorial was fitted with tables that listed the names of soldiers from the "Keystone State." Other northern states gradually followed suit. For a long time the only memorials were from northern states, but in time the South too began to be represented. In 1933, Alabama unveiled its spectacularly beautiful monument. North Carolina commissioned the sculptor of Mount Rushmore, Gutzon Borglum, to create its modest but profoundly moving monument. Perhaps the most striking of all is the Virginia State Memorial, which cost $50,000, and was dedicated on June 6, 1917. It features a breathtaking equestrian statue of Gen. R. E. Lee, and stands on the spot from which Lee watched the ill-fated Pickett's Charge. (For far too many years, James Longstreet—who had become the victim of a character assassination movement in the late nineteenth century—was not honored at Gettysburg or anywhere else. In the summer of 1998 that was at last rectified. Down the road from the Virginia monument, along the same battle line, was unveiled another equestrian statue: Lee's "Old War Horse," the second in command of the Army of Northern Virginia: James Longstreet. It was, as Edwin C. Bearss—one of the speakers for the occasion—said, *about time*"!)

A major event, the twenty-fifth anniversary of the battle, sparked much attention and activity. On July 3–4, 1888, there was a reenactment of Pickett's Charge and the dedication of

133 regimental monuments. (Reenactment, which is so popular today as to fairly be called a "civil religion," was begun by the *veterans themselves*!)

Thus far the memorials and markings, as well as land acquisition, were exclusively northern commemorations. Various congressional efforts during the late 1880s and early 1890s resulted in the establishment of the Gettysburg National Military Park. The first park commission comprised John P. Nicholson, John B. Bachelder, and William H. Forney. The bill to establish the park was passed by Congress; President Grover Cleveland signed it into law on February 11, 1895. The Gettysburg Battlefield Memorial Association then turned its holdings over to the federal government. The park then included 522 acres, some 17 miles of avenues, most just dirt paths, and 320 monuments.

During the 1890s veterans from both sides who labored to secure funding and information for bronze or iron plaques oversaw the emplacement of 324 of them: 160 Federal and 164 Confederate. Recently, George R. Lange, a retired lieutenant colonel of artillery in the U.S. Army, wrote a book that includes complete transcriptions from all of these plaques. It is titled *Battle of Gettysburg: The Official History by the Gettysburg National Military Park Commission* (Shippensburg, Pa.: Burd Street Press, 1999). The book also includes a short history of the park commission, some summation of each day's action as well as of the aftermath of the battle, and information from nineteen itinerary tables, which are now in storage and not on display, that explained the routes taken to Gettysburg by the opposing forces.

A landmark decision by the United States Supreme Court on January 27, 1896, allowed the government to condemn private land to further preserve the battlefield. This decision was of crucial importance not only to this area, where railroad construction threatened to intrude onto the battlefield, but also to areas of historic importance all over the United States.

Iron markers were placed from time to time during the 1890s to spot the locations of U.S. Army Regulars during the battle. Various regimental associations made contributions to pay for the erection of a large obelisk commemorating the Regulars, and on May 31, 1909, these all were dedicated in a ceremony that featured President William H. Taft as principal speaker.

The four-day fiftieth anniversary commemoration, July 1–4, 1913, was a major event. More than 50,000 Civil War veterans attended, each served by an aide, a member of the Boy Scouts

of America (which had been founded in 1910—this being the first major national publicity which that organization garnered). President Woodrow Wilson delivered an address. And on July 3, 120 veterans from George Pickett's division "charged" 180 veterans of the Philadelphia Brigade from a distance of 100 feet. They met at the stone wall for a ceremonial handshake—the famous scene "hands across the wall."

The ignorance of battlefield guides often was the subject of complaints, so in 1915 the War Department issued guidelines for licensing them, and written examinations were thereafter required.

The park was often used for military training purposes, and especially during World War I, it served as a proving ground for tank units before they were shipped overseas.

The Department of the Interior took over administration of the park in 1933. This marked the culmination of a seventeen-year-long campaign to consolidate the administration of all federal parks and monuments under the National Park Service.

The seventy-fifth anniversary of the battle, July 1–4, 1938, drew much attention. Now only 1,845 veterans attended. President Franklin Roosevelt dedicated the Eternal Light Peace Memorial before a crowd of some 200,000 people.

The centennial commemoration July 1–3, 1963, brought the largest crowds ever to the battlefield. The Park Service estimated that for the entire year there were 2,041,378 visitors—the first time that the number had exceeded 2,000,000.

Reenactments are no longer allowed on the battlefield itself—owing not only to the obvious danger of damage to the terrain and memorials, but also to the inclination of too many modern reenactors to actually try to hurt one another! Reenactments are held on nearby similar terrain. On the battlefield itself, however, there are allowed "living history" demonstrations.

The park now contains more than 90 period buildings, including General Meade's headquarters and several barns and houses that figured prominently in the fighting. There are more than 1,300 monuments and markers and quite a few more than 350 cannon—indeed, almost as many as were in the battle. There have been recent efforts to return foliage and crop plantings of the more than 5,000 acres of parkland to their 1863 appearance.

The work of preservation and improvement goes on and must continue to go on; all too often are there outrageous projects, meldings, meanderings, and tower-constructions (for example) that mar the appearance of this most sacred

battleground. One magnificent step was taken on July 3, 2000, when explosive charges brought down the National Tower, a most notorious eyesore. A "soaring steel structure," with a "hyperbolic hourglass shape," it provided a "unique, for-profit overview of the park" (some guides even liked it, because it always offered a reference point to visitors *any-where* in the park), but huge numbers of folk considered it hideous. To his credit, Interior Secretary Bruce Babbitt vowed in April 1999 to level it "on my watch."

A very excellent little well-illustrated book by William C. Davis, *Gettysburg: The Story behind the Scenery* (Las Vegas, Nev.: KC Publications, 1995), is a fine start for folk who wish to know still more about the park's development. We would also keenly recommend *Hands across the Wall: The Fiftieth and Seventy-fifth Reunions of the Gettysburg Battle* by Stan Cohen (Charleston, W.V.: Pictorial Histories Publishing Co., 1982).

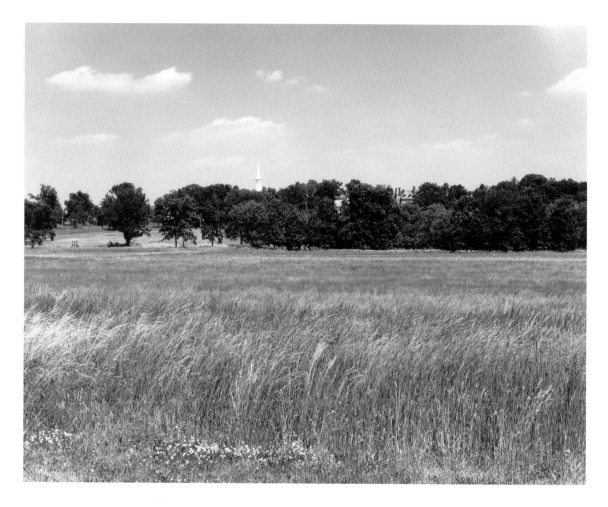

VIEW OF BATTLEFIELD
Lutheran Theological Seminary.

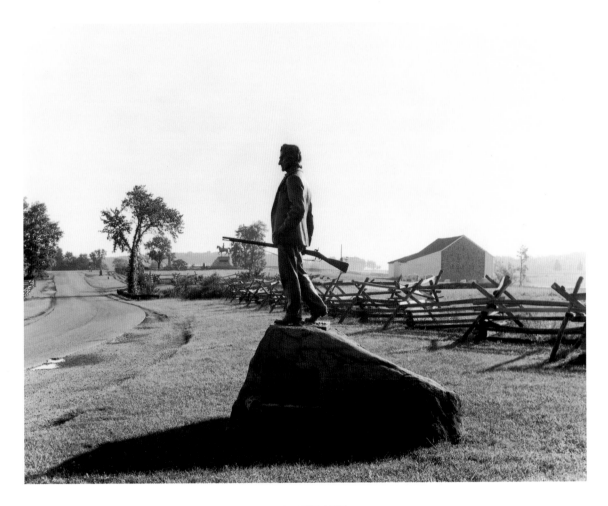

MONUMENT
John Burns, Citizen Soldier.

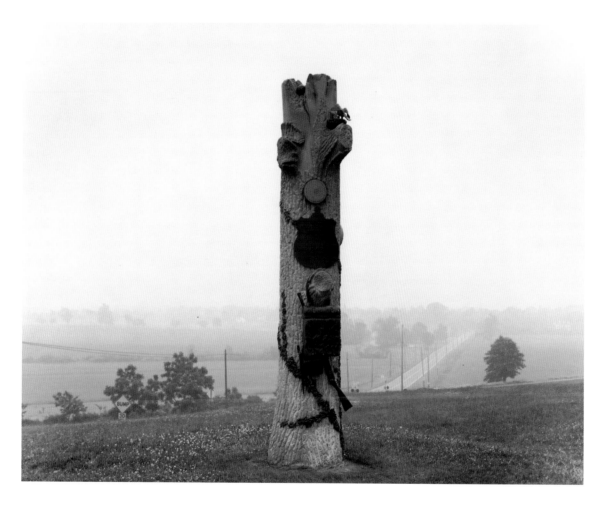

MONUMENT
Ninety-sixth Pennsylvania Infantry, Double Day Avenue.

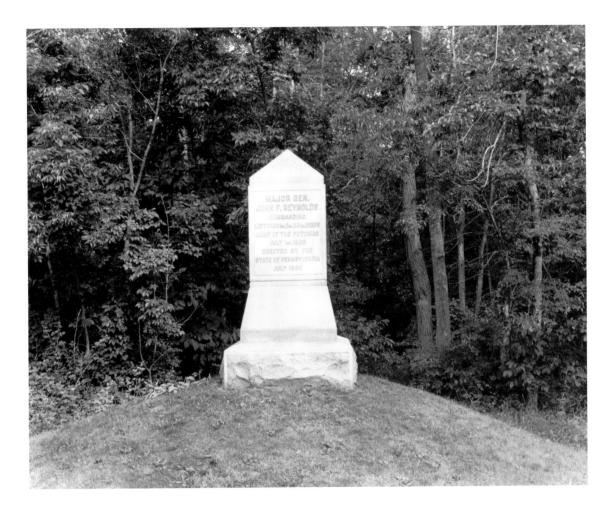

GRAVE MARKER
Maj. Gen. John F. Reynolds.

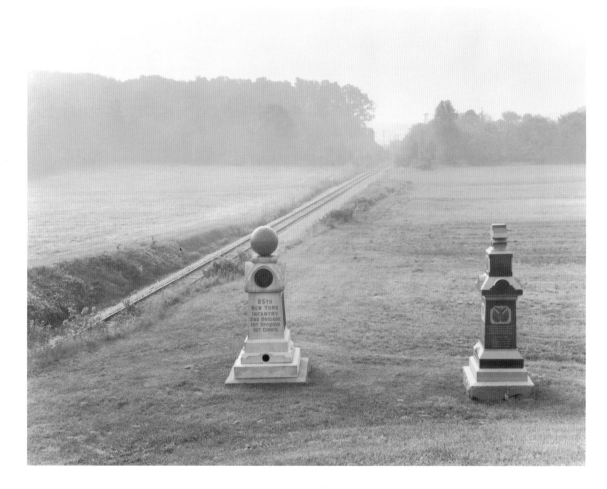

MONUMENTS
Along Railroad West of Gettysburg.

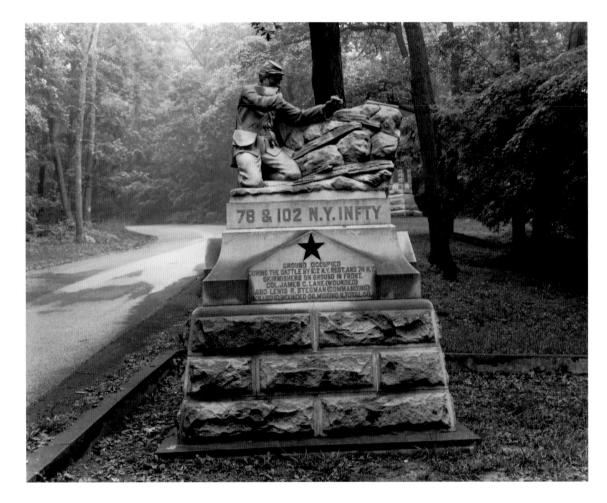

MONUMENT
78th and 102d New York Infantry, Culp's Hill.

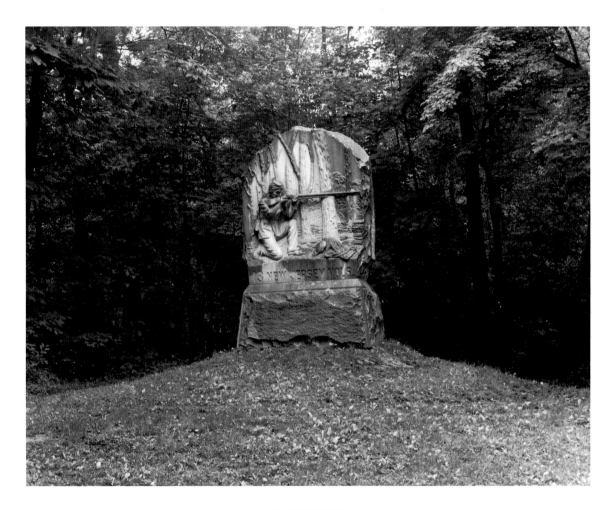

MONUMENT
Thirteenth New Jersey Volunteers, Culp's Hill.

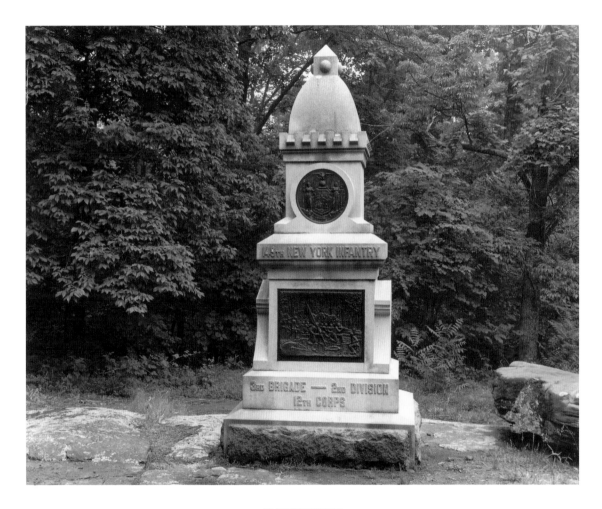

MONUMENT
148th New York Infantry.

22

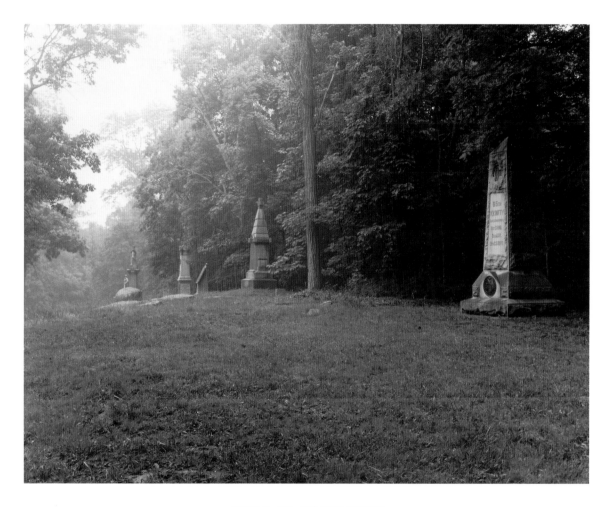

FIELD OF MONUMENTS
Culp's Hill.

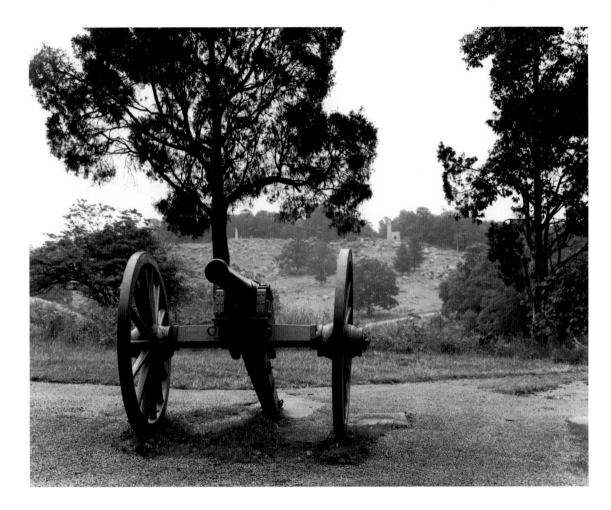

CANNON DISPLAY
Devil's Den.

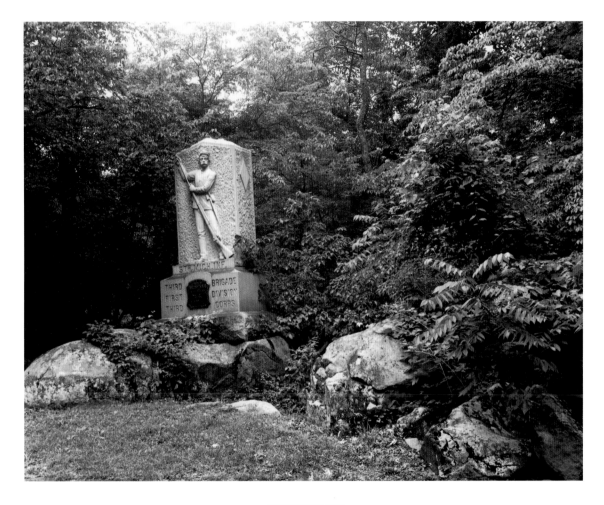

MONUMENT
Fifth Michigan Infantry, Devil's Den.

"REBEL SHARPSHOOTER"
Site of Timothy O'Sullivan's Famous Photograph.

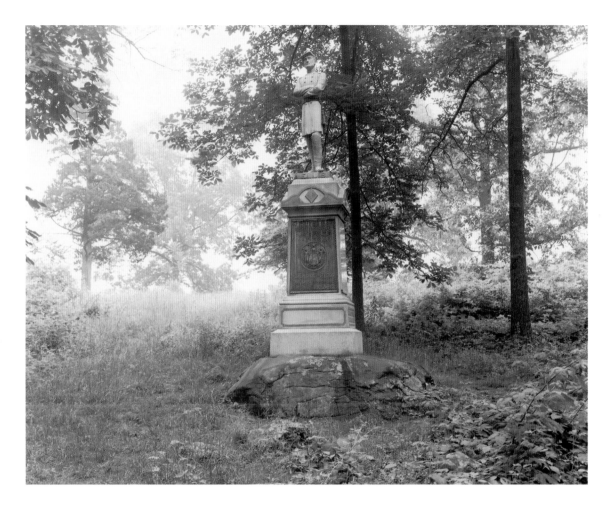

MONUMENT
Col. Theodore Ellis and 124th New York Infantry.

MONUMENT
Standing Infantryman, Tenth Pennsylvania Reserve, Little Round Top.

MONUMENT
Eighty-third Pennsylvania Infantry, Little Round Top.

MONUMENT
Twentieth Maine Regiment, Little Round Top.

MONUMENT
Standing Infantryman, 121st New York Infantry, Little Round Top.

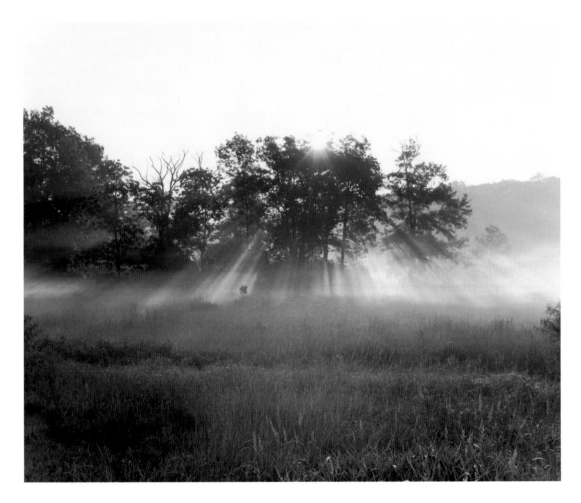

Sunrise over the Valley of Death.

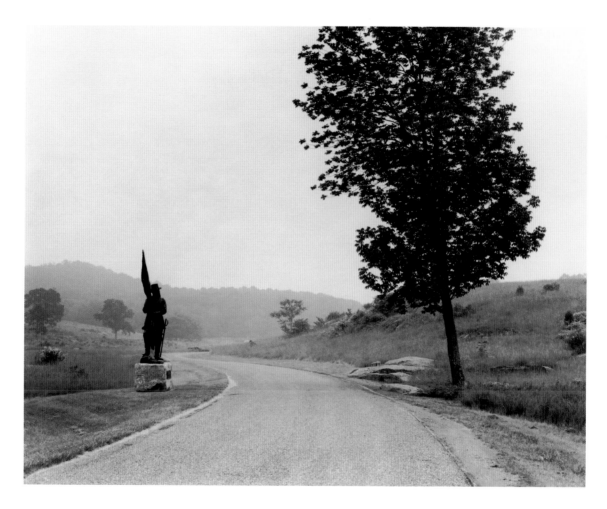

MONUMENT
Brig. Gen. Samuel W. Crawford, U.S.A., and tree, Valley of Death.

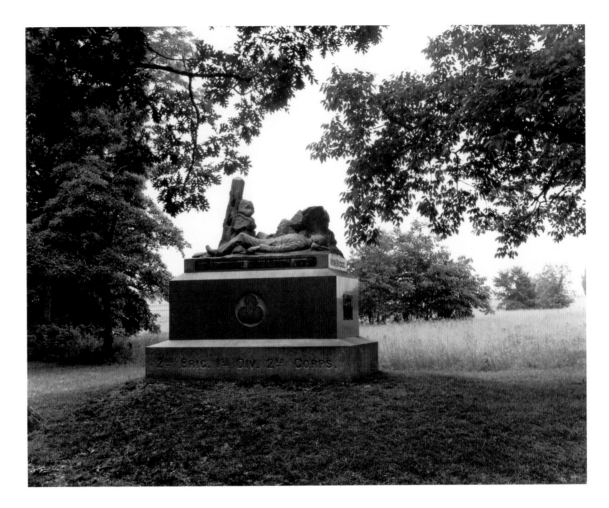

MONUMENT
Dying Soldier, 118th Pennsylvania Infantry, Irish Brigade.

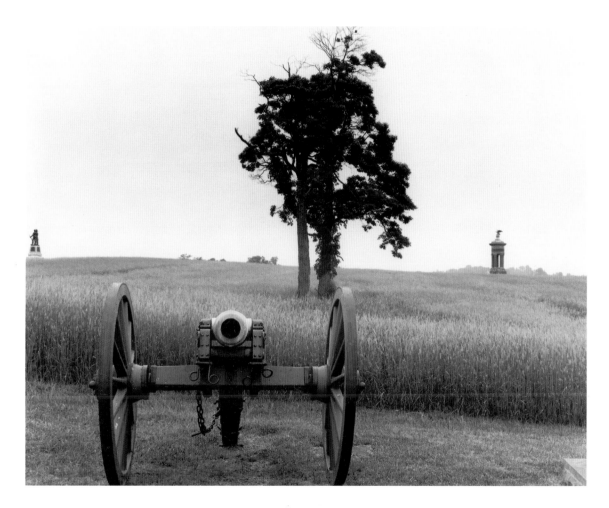

CANNON DISPLAY
Near Peach Orchard.

MONUMENT
Clenched Fist, Eleventh Massachusetts Infantry, near Peach Orchard.

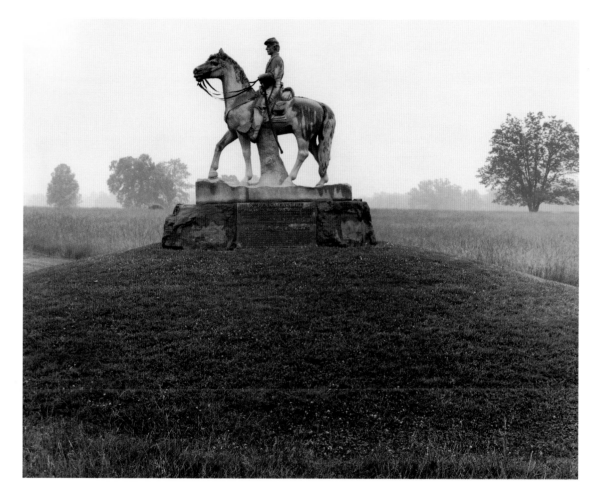

MONUMENT
Horse and Rider, Eighth Pennsylvania Cavalry, Pleasonton Avenue.

MONUMENTS
Cavalry, Gettysburg.

VIEW OF BATTLEFIELD
Near Peach Orchard.

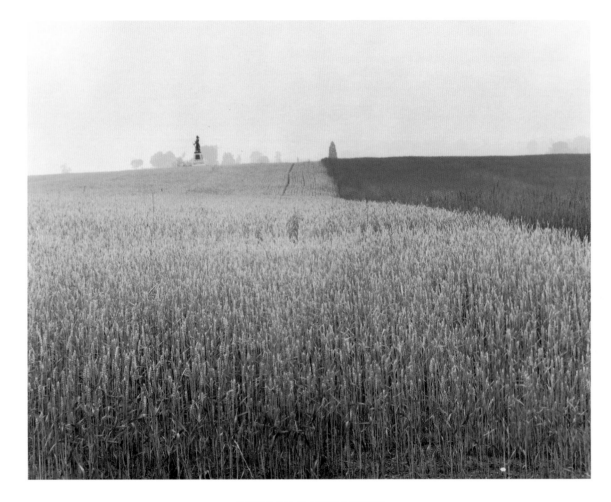

VIEW OF BATTLEFIELD
Looking over Wheatfield from U. S. Avenue.

VIEW FROM CONFEDERATE LINES
Facing Union Center, Pickett's Charge.

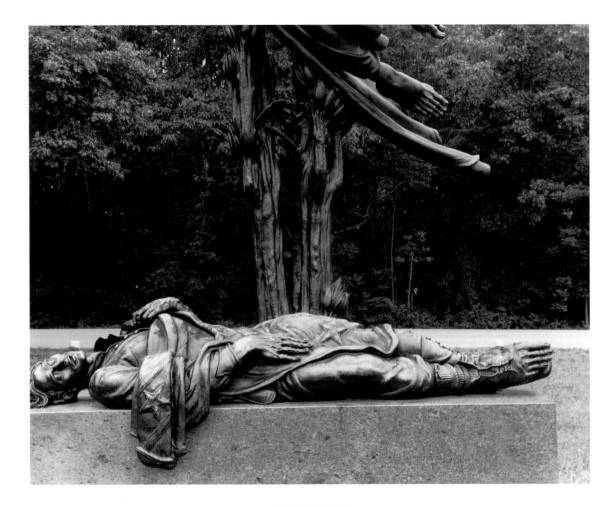

MONUMENT
Dead Confederate Soldier, Detail, Louisiana Memorial.

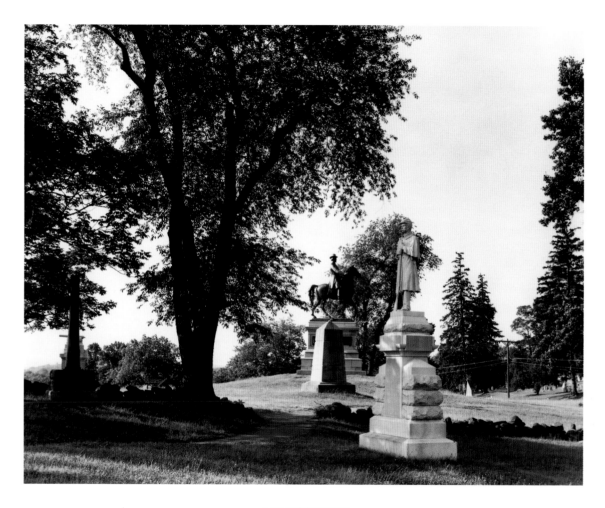

MONUMENTS
Atop Cemetery Hill.

43

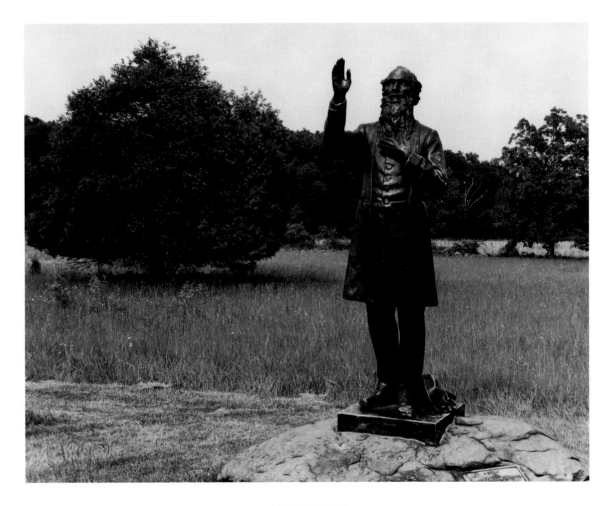

MONUMENT
Father William Corby.

VIEW OF BATTLEFIELD
Confederate Retreat, Pickett's Charge.

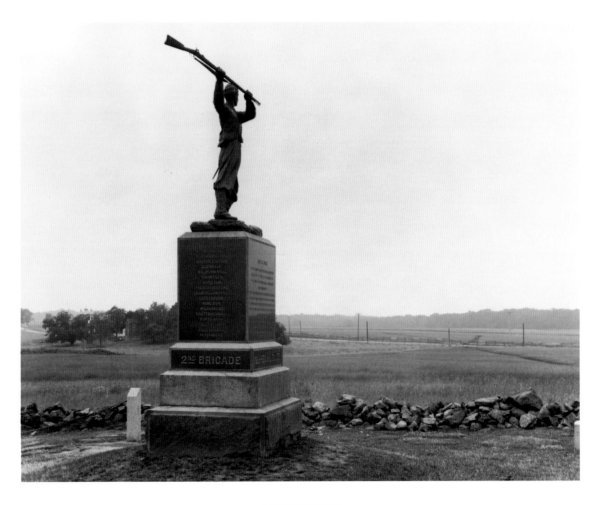

MONUMENT
Fighting Infantryman, Second Brigade, Pennsylvania Volunteers, the Angle.

MONUMENT
Confederate High-Water Mark.

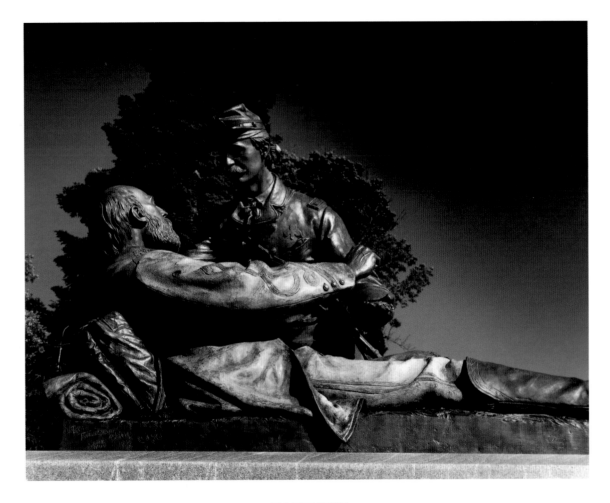

MONUMENT
"Friend to Friend," Armistead and Hancock, Masonic Memorial.

II

Chickamauga-Chattanooga-Missionary Ridge

II

Chickamauga-Chattanooga-Missionary Ridge

I**T IS TOO EASY**, and misleading, to think of the Civil War's outcome as already decided by early July 1863. As to its total duration, the conflict was then but only a little past the halfway point. The Confederacy took in a huge area: larger than any European nation except Russia and Turkey. It was not a simple thing to subdue the people in so large a would-be country.

True, after Gettysburg, R. E. Lee's eastern army was weakened significantly, and in the West the Confederacy had been split geographically, but the Confederacy still retained a remarkable degree of viable potency. It proved able to redeploy internally and score a morale-boosting victory at Chickamauga in late September 1863. In addition to triumph in battle, determination and popular will, effective propaganda, political manipulation, guerrilla activity, raids, and technical achievement all *can* contribute to the final results in warfare.

A major reality that makes the Civil War *so* interesting is that from every material standpoint the South was by far the weaker side. But, after the twin disasters of Gettysburg and Vicksburg, the South still would thereafter succeed remarkably well in raiding—just a few weeks later John Hunt Morgan led his marauders into Ohio and Indiana—and before the final flashes of will to resist were at last quashed, the South actually had launched an operational submarine and had destroyed a blockading vessel with it. Most significant of all would be the triumph at Chickamauga. Alas, for the South's hopes, however, that was too soon followed by disasters at Chattanooga and Missionary Ridge.

Aside from destroying or curbing the combat capabilities of the enemy's field armies, the North's grand strategy was, and continued to be, the taking of the Confederate capital at Richmond, and the securing of an area in the western theater where there was a considerable enclave of pro-Unionist Southerners: east Tennessee.

None of Lincoln's generals gratified his desires for decisive action; he wanted his Western commanders to advance in force directly into east Tennessee. But all of them objected that the rough terrain and lack of good roads made direct advance impossible. Instead, Union Gen. Don Carlos Buell and his successor, William S. Rosecrans, opted to move on an axis through middle Tennessee, and then southeastward to Chattanooga. That relatively small city of just 4,200 citizens occupied a most significant strategic location: roads, railroads, river, and mountains all made it not only a viable gateway to the coveted east Tennessee, and its principal city of Knoxville, but also to the Deep South.

A series of maneuvers that led to the spectacular clash, the Battle of Chickamauga, began in mid-August 1863. Rosecrans and his army had advanced into much of Tennessee in the relatively bloodless but successful Tullahoma campaign. Now this force was only a few dozen miles northwest of Chattanooga. But Washington authorities, unfazed by the Tullahoma campaign, impatiently urged Rosecrans to get on with things. On August 16, Rosecrans pushed his army forward.

His plan was a daring one. He would divide his army, with each of the three corps taking a different route. The principal Confederate army, under Gen. Braxton Bragg, became the target of an attempted ensnarement. The Twenty-first Corps, under Maj. Gen. Thomas L. Crittenden, would threaten Chattanooga directly, and then move upriver along the Tennessee around Lookout Point. The Fourteenth Corps, under Maj. Gen. George H. Thomas, would advance eighteen miles to the south of Crittenden's force and pass through Steven's Gap. Still farther to the south, Maj. Gen. Alexander McCook's Twentieth Corps would advance through Winston's Gap— forty-two miles from Chattanooga.

Bragg rightly felt compelled to take Crittenden's fake advance on Chattanooga seriously. But Rosecrans managed to catch Bragg somewhat by surprise and turned the Confederate army, forcing it to retreat rather than run the risk of being shut in at Chattanooga, subject to a siege. Bragg, though, was not totally without wit: he had carefully rehearsed "deserters" depart from his army to the Federal lines, where they told tales of utter demoralization within the Confederate army.

Bragg was being given other help as well. Already reinforcements had begun arriving from Mississippi, and significantly more—James Longstreet's corps—were on the way by train from Virginia. Bragg began to concentrate his force at La Fayette, Georgia, opposite Steven's Gap. Unluckily for the South, two sterling opportunities to strike at portions of the nearby Federal army were frittered away owing to disgruntlement among Bragg's subordinate generals.

Rosecrans ultimately realized the danger he was in, drew his army together, and began a sidling movement northward, along the west bank of Chickamauga Creek, trying to get back into secure positions at Chattanooga. By the evening of September 17, Bragg's gradually arriving reinforcements had swelled his numbers to about 65,000 men. Rosecrans had only about 62,000, with his left (northern) flank at Lee and Gordon's Mill on Chickamauga Creek. The bulk of Bragg's army was farther north on the east bank. Bragg knew he had to somehow get his army across that creek.

On September 18 the Confederates fought their way across the creek, seizing first Reed's Bridge and then Alexander's Bridge farther upstream, which was a bit closer to Lee and Gordon's Mill. Nonetheless, the Union cavalry not only harassed and delayed the Confederate crossings, it also gave Rosecrans useful information concerning the enemy loca-

tions. The Battle of Chickamauga really took place on September 18, 19, and 20, 1863 (instead of the usually cited 19–20). It is what did not happen on the eighteenth that dictated conditions on the nineteenth.

Bragg began September 19 in hopes of driving southwestward, hitting the Union flank, and forcing the enemy army into McLemore's Cove where, having cut it off from retreat, the Confederates might inflict grave damage upon it. Rosecrans on the other hand wanted to keep sidling northward and get between Bragg and Chattanooga. As both commanders tried haplessly to carry out their planned movements, the men of the two armies stumbled into the complex and thoroughly ferocious fighting of the ensuing day's actions.

Capitalizing on his intelligence, Rosecrans had three divisions of Thomas's Fourteenth Corps on a night march to Kelly Field, about three miles to the north of his previous northern flank which had been at Lee and Gordon's Mill. So at the outset of the day's struggle, Bragg was unaware that instead of attacking the enemy's left flank, he had the enemy situated on his own right flank. The forces collided in initial combat shortly after dawn. Thomas got an inaccurate report that only a single Confederate brigade was already west of Chickamauga Creek; so he sent a division forward. In fact, Thomas's ad-

vancing division was thrusting toward almost the entirety of the Confederate army, but doing so on the Confederate right flank. Patrolling that flank was the cavalry under Maj. Gen. Nathan Bedford Forrest.

Absorbing the first shock wave of the Union's advance, Forrest's men performed well, and soon were being bolstered by infantrymen sent by Bragg in support. Thomas sent more of his divisions into the woods, toward the creek, and Rosecrans shuffled more and more of his troops northward from the positions they had been holding south of Lee and Gordon's Mill.

The battle grew in intensity and spread southward as the bulk of both armies shifted to the south of the point of initial contact. Rosecrans clung to a main goal, throughout the entirety of the ongoing conflict, of holding onto control of the La Fayette Road, his primary—though not sole—link to Chattanooga. Bragg, with his initial plan obviously gone awry, sought to maintain maximal contact with the enemy force and to inflict as much damage upon it as now possible.

By midday the Federals were enjoying the advantage, having driven the Confederates beck in the Winfrey Field sector, the north-central part of the battlefield. There was particularly sanguinary fighting across the Viniard Farm and in the surrounding woods. But late in the afternoon, a gap opened in the Federal line, between those men situated at the Viniard Farm and those engaged in fighting farther north. The opening of this gap, accompanied by the advance of Confederate Maj. Gen. Alexander P. Stewart's division, precipitated the major crisis of the day for Rosecrans. Suddenly a significant segment of the Union center collapsed in the Brotherton Field. Gleeful Confederates surged forward in pursuit. But luck was with Rosecrans, for those advancing enemy troops were not subsequently given needed support, and Rosecrans was able to counter them by shifting his own reinforcements to this sector. By sundown the front was again stable.

But the fighting of September 19 was not yet over. As the sun began to set, Confederate Maj. Gen. Patrick R. Cleburne's division, a crack outfit, moved up from the position it had been holding on the creek's east bank just south of Lee and Gordon's Mill and crossed to the west bank squarely behind Bragg's center. A confused nighttime battle in the Winfrey Field and in the surrounding woods ensued. But, while *marching* at night in conditions of the era might be viable, *actually engaging in combat* in darkness was rarely if ever so. The result was an eerie struggle, some considerable additions to the numbers of dead and wounded, but little more save for depleting the effectiveness of Cleburne's sterling force, and leaving it ill-deployed for the fighting that would continue the next day.

The fighting did continue the next day, but it started three hours later than Bragg had intended, owing to misunderstanding of orders. John C. Breckenridge's division, in the lead, did manage to get around the Union left flank, but before his success could be exploited Union reinforcements moved to block and drive Breckenridge's men back. There was other fighting, all dreadfully sanguinary, but indecisive.

Then, shortly before midday, there commenced the dramatic episode that marked the turning point of the whole engagement, and that ultimately resulted in a tremendous Confederate triumph. Longstreet advanced his wing in a power column formation. This was all due to overly hasty and ill-chosen troop redeployments by the Yankees. Rosecrans was very tired and harried—even much more than usual!

The problem developed at the edges of the positions occupied by Maj. Gen. George H. Thomas's Fourteenth Corps and Maj. Gen. Thomas L. Crittenden's Twenty-first Corps. Brig. Gen. Joseph J. Reynolds's Fourth Division, Fourteenth Corps, was flanked on its right by Brig. Gen John M. Brannan's Third Division, Fourteenth Corps. The Twenty-first Corps occupied the stretch of emplacements to the right. Rosecrans acted on the incorrect assumption that Brannan's Brigade had moved out, which it earlier had been instructed to do, to support combat operations farther to the Union left. Rosecrans sent a written order to Brig. Gen. Thomas J. Wood to move his First Division, Twenty-second Corps to "close up" on Reynolds's division and "support" it. This was an ambiguous order, for to close up would simply mean to make contact with a flank, but to support meant to march around behind and bolster a defensive position making a stand. Wood pulled his division out of line and marched it north to come behind Reynolds—and all the way beyond the position still occupied by Brannan. This left a six hundred–yard unoccupied gap in the Federal line, and it proved to be at the worst of all possible times and places, because Longstreet's assaulting column poured into it.

There were valiant efforts made by numerous Federal artillery batteries and particularly by the infantry of Maj. Gen. Philip H. Sheridan's Third Division, Twentieth Corps. Only a semblance of Union integrity could be maintained while the bulk of the army along with two of its corps commanders, Alexander M. McCook and Thomas L. Crittenden, and the army commander himself, Rosecrans, skeddadled all the way back into Chattanooga.

Only on the Union far left did remaining troops manage to foment a fairly formidable resistance. On a chain of hills, dominated by Snodgrass Hill, the heavily reinforced Fourteenth

Corps stood stoutly, and some of the remnants from the broken Union center rallied to the right rear of that position. It is what prevented a complete rout of the Union army and possibly the storming into Chattanooga by the victorious Rebel army. The great credit for what occurred at Snodgrass Hill truly belongs to a coterie of lower-echelon officers who seized the initiative in forming up the position: Brig. Gen. Thomas J. Wood, Col. Charles G. Harker, Brig. Gen. John M. Brannan, Col. Moses Walker, and Col. Morton C. Hunter. George H. Thomas, later honored with the sobriquet "the Rock of Chickamauga," was simply fortunate to have had their services and initiative. As the senior he took charge and directed the defensive stand after it already had commenced, but the initial actions were taken without any input at all from him.

Bragg correctly assessed that his enemy was still strong and potent, and so he chose not to risk an assault upon Chattanooga. Instead, he proceeded to occupy strong positions on Missionary Ridge and Lookout Mountain and placed the city under siege. There were foreign observers at the Battle of Chickamauga, and they were deeply impressed with the carnage. A reporter for *Le Figaro* (Paris) said of this battle: "These Americans are fighting on a military system inaugurated by the Kilnenny cats. The two armies meet and fight and slaughter each other with the utmost fury. Then they fall back and reorganize for another general massacre. Positively, the war will end when the last man is killed."

Probably the most thorough of the many books available about the Battle of Chickamauga is Peter Cozzens's *This Terrible Sound* (Urbana: University of Illinois Press, 1992).

The Confederacy's failure to capitalize meaningfully on its victory at Chickamauga proved to be quite a significant shortcoming. Bragg had not realized how great his victory was. Shortly after the battle, unsure even that the Yankees truly were in full retreat to Chattanooga, Bragg interviewed a Rebel private who had been captured and then had escaped. "Do you know what a retreat looks like?" Bragg sternly inquired of the man. "I ought to, General," he allegedly replied. "I've been with you during your whole campaign."

The Federal Army of the Cumberland was indeed badly hurt, and the time to have attacked it again was after a couple of days, three or four at most. As was always the case with battered Civil War armies, this one soon commenced to recover. Further, the Federal high command decided to send the Eleventh and Twelfth Corps from the Army of the Potomac, combined under the command of Maj. Gen. Joseph Hooker, west to Rosecrans. Some skeptics thought this would

take a month or more, but Union Secretary of War Edwin M. Stanton predicted it could be done in the incredibly short span of seven days. Telegrams were dispatched to the railroad officials and to the army, rail lines were commandeered, red tape was broken, and the job was one. The first troops moved on September 25, and by October 2 the last of them had arrived in Alabama, from there to march to Chattanooga. It was a brilliant and superlative logistical operation. Some twenty-five thousand troops—four infantry divisions and ten batteries of artillery with all their weapons and equipment and three thousand draft animals—were transported twelve hundred miles in the fastest overland movement of so large a body of combat troops to that time in the history of warfare.

Meanwhile, crucial changes in Union command assignments occurred. On October 16 the Federals created the Military Division of the Mississippi, combining the Departments of the Ohio, the Cumberland, and the Tennessee. U. S. Grant was given the new command, and one of his first acts was to give Rosecrans the axe, and to elevate Maj. Gen. Thomas "the Rock of Chickamauga" as his replacement. In Grant's former position, Maj. Gen. William T. Sherman took over the Department of the Tennessee, while Ambrose E. Burnside would continue in command of the Department of the Ohio. Sherman moved overland from Mississippi with twenty thousand men to bolster the Federal forces at Chattanooga. Grant himself turned his personal attentions to attenuating the problems there.

The so-called Confederate siege of Chattanooga proved an easy thing to lift. The investment was too tenuous and not complete. Some of Hooker's units were able to clear the Rebels from Cummings Gap, which divides Raccoon Mountain. Then the Union troops thrust straight to the Tennessee River and seized Kelly's Ferry. On October 27, in a daring operation, a pontoon bridge was thrown across the Tennessee River at Brown's Ferry, and a line of supply was thus opened—soon dubbed "the Cracker line"—from Lookout Valley to Bridgeport. Within a few days full complements of supplies were coming through. The Confederates failed to make any significant response.

During the night of October 28–29, Longstreet's corps attacked Brig. Gen. John W. Geary's Second Division of Hooker's corps, at Wauhatchie Station, a stop in Lookout Valley along the Nashville and Chattanooga Railroad. If the Confederates could have taken that place, they would thus have cut off Hooker's rear. Although it was one of the few important night engagements of the war, Wauhatchie Station was a piecemeal and ill-conducted encounter. Capturing Union pickets and killing the sentries, the Rebels achieved initial surprise. Kicking out their campfires, the Yankees formed

a V-shaped battle line, supported in the rear by a battery of artillery. A squad of Confederate sharpshooters managed to work around behind, firing on the cannoneers throughout the night. But because the moon was periodically covered over by heavy clouds, visibility was impaired, and often the only targets anyone saw to shoot at were muzzle flashes. When Hooker heard the sound of firing he had ordered out reinforcements, and later still more Federal troops bolstered the position. The Rebels elected to retire to Lookout Mountain, and the confused engagement at Wauhatchie Station ended at 4:00 A.M. with the Cracker Line still secure.

The Confederate army meanwhile was tottering toward disharmony among its generals. Bragg felt that Longstreet was uncooperative, while there was near-mutiny among many of the other top subordinates. President Jefferson Davis personally visited the army and did what he could to remedy the situation. Longstreet was later dispatched with his corps to try and secure Knoxville. Polk was transferred, A. P. Hill demoted and transferred, and Simon B. Buckner effectively demoted despite no change in his rank. Thomas C. Hindman escaped the hammer only because he had been badly wounded in the Battle of Chickamauga. But these shufflings did not adequately quell the army's problems, and as time

passed the troops grew more and more disheartened. And by November 23, when Grant launched the Battle of Chattanooga, the Confederates were at a moderate disadvantage in numbers.

Maj. Gen. George H. Thomas's Army of the Cumberland moved forward, with two divisions from Fort Wood, toward Orchard Knob, an eminence held by the Confederates about a mile in front of the main Rebel position on Missionary Ridge. The divisions of Maj. Gen. Philip H. Sheridan and Brig. Gen. T. J. Wood drove out the Confederates and captured Orchard Knob, suffering only a few casualties. Grant now lined up his units for the primary thrust. During the ensuing night Sherman, north of the Tennessee River, sent a brigade across the water near South Chickamauga Creek to make a foothold and prepare a bridge.

The next day, November 24, occurred the Battle of Lookout Mountain, also dubbed "the Battle above the Clouds." Three Federal divisions under Joe Hooker crossed Lookout Creek and began the difficult climb up Lookout Mountain, in hopes of driving the sparse Confederate defenders from the heights above. The Confederates offered major resistance at Craven's Farm, a bench of fairly level land on the mountainside where Mr. Craven had an ironworks. Heavy fog enshrouded the crest from view of the Federals in Chat-

tanooga—hence the episode's nickname. By the end of the day the Federals had secured Lookout Mountain, there being no fighting on the mountaintop itself with the Confederates withdrawing to Missionary Ridge. There were but few losses and the fighting had been relatively light, but it was a significant step for the Federals in forcing their enemy to concentrate on what proved to be an inopportune stretch of high ground.

Missionary Ridge is approximately forty miles long. The northern-most point is near Chattanooga, while the southern-most one is at McLemore's Cave. It is approximately two miles wide. The western slope—the Confederate front—is very steep, craggy, and very irregular. The Confederate artillery was located on the topographical crest, always disadvantageous when contrasted with the "military crest"—e.g. low enough so as to minimize dead space to the front so that the gun tubes can be sufficiently depressed. But here, more nearly in truth, there was no military crest. To have most effectively covered the front would have required the Confederates to eschew direct frontal fire, and fire instead at oblique angles. Couple these realities with the low morale within the Rebel ranks, contrasted with the now-supercharged fighting spirit of the Yankees, and the situation was a precarious one for Bragg's army.

Grant's plan produced victory on November 24, but ultimately in a different manner than he originally had planned. What he had wanted was for Sherman's army to crush Bragg's right at the far end of Missionary Ridge. But Sherman encountered difficulty, and his troops faltered. Grant subsequently tried the other end of the enemy line, near Rossville Gap. But this too was stymied. So, with both flank attacks stalled, Grant decided to try and snatch the best he thought he could: a toehold in the rifle pits at the base of Missionary Ridge. About 3:30 P.M. he ordered George H. Thomas to have his men do that. But, after the men secured the rifle pits, they kept on going—all the way to the top. When Federals here and there managed to capture Rebel gun emplacements at the crest, the Yankees then turned the guns laterally on their soon totally vanquished enemies. It was a spectacular victory.

Only on the north end of the Ridge, where the division of Maj. Gen. Pat Cleburne had managed to hold Sherman's force off all day at Tunnel Hill, did the Confederate forces manage to maintain any measure of cohesion. It was around and beyond Cleburne's defenders that the fleeing Rebels escaped. Exhaustion and gathering darkness eventually stopped the Union advance. Cleburne and his force then slowly withdrew, covering the Confederate army's disorderly retreat—which went all the way back to Chickamauga Creek.

"My God," cried one Indiana private after the Yankee victory had become evident, "come and see them run!" Philip Sheridan leaped astride one of the Rebel cannon barrels, and wrapping his short legs around it, he waved his hat and cheered. The unfortunate Colonel Harker, however, had a much more unhappy experience on the ridge crest. He decided to jump up on a gun and cheer, too; but he mistakenly chose a piece that only shortly before had been fired, and he scorched his behind so badly that he was unable to ride a horse for more than a week.

Bragg's army crossed Chickamauga Creek that night. Despite the desperate fighting, casualties were relatively low for a major battle: the Federals had engaged some 56,000 men, with a total of 5,824 casualties; Confederates engaged numbered about 46,000, with 6,667 casualties, many of them having been taken as prisoners. Thus was the route for a Yankee invasion of Georgia now partially opened. The defeat at Chattanooga precipitated Bragg's resignation from field command, at long last, for it was long overdue. Most important, the episode was the final catalyst in ensuring Grant's elevation, which came early in 1864, to the rank of lieutenant general and his assuming the overall command of all the armies of the United States.

The park was officially dedicated, with impressive ceremonies, on September 18–20, 1895. The original three park commissioners, all veterans of Chickamauga or Chattanooga, placed hundreds of cast-iron plaques and other markers on the battlefields in the early 1890s. Hundreds of other veterans contributed information. More than six hundred stone and bronze monuments were erected between 1890 and 1930.

Most of the fourteen hundred monuments and historical markers were planned and placed by Boynton and other veterans of the battles. There are approximately five thousand acres in the National Park, which make up 75 to 80 percent of the main battle area. But, the park includes very little of Chickamauga Creek.

There now is a lone climbable observation tower at Chickamauga. Three others, made of steel, were condemned as unsafe and dismantled.

Georgia's monument, at eighty-seven feet, is the tallest in Chickamauga Park.

The New York Peace Monument at Point Park on Lookout Mountain was dedicated in 1910 at a cost of nearly $80,000. It is Tennessee marble and pink granite and the tallest in this particular park.

Part of the impetus for the War Department's interest in having national military parks at all was to use them for teaching lessons to the soldiers of later generations. Maneuvers were held at them, and in 1898, with America at war with Spain over Cuba and Puerto Rico, huge masses of troops were sent to Chick-Chat (as this park came to be known informally) for mobilization and training. This was repeated later, during World Wars I and II, on a larger scale.

Eventually Chick-Chat grew to include 666 monuments, 255 cannon, and 650 markers and informational tablets. There are two National Park Service visitor centers: one on the Chickamauga and the other atop Lookout Mountain.

Most of the battlefield of Chickamauga is in the park, which has miles of roads and hiking trails. While originally entirely a Union commemoration, Florida, Texas, Kentucky, Georgia, and South Carolina all have placed monuments on the field. The main visitor center contains the Fuller Gun Collection, one of the finest collections of military small arms in the entire nation; and it has a quintessential audio-visual program; it sets the standard for all others.

North of Chickamauga the rest of the park protects most of the slopes and the northern point of Lookout Mountain. Point Park overlooks Chattanooga and east to Missionary Ridge. Here is located the site where an untold multitude of folk ever since the battle occurred have posed to have their photographs taken, against so breathtaking and stunning a backdrop.

Missionary Ridge, by contrast, is inundated by housing. Many of the historical tablets are in people's front yards, or embedded in the fences that surround their property. Here and there are scattered monuments, some of them rather hard to see or to appreciate. There are only selected areas along Crest Drive that are actually part of the park: "reservations" named for the states of Ohio and Iowa and for certain officers involved in the battle. Orchard Knob, where Grant watched the spectacular assault that carried to the top of Missionary Ridge, is a reservation too.

Thus does Chickamauga-Chattanooga National Military Park, with over eight thousand acres, constitute the largest of

our Civil War parks, and in many ways is it the most inclusive. It is perhaps ironic that the site of Battle of Chickamauga should be so well preserved, and so much can indeed be learned there, while urbanization has made the Battle of Chattanooga a bit difficult to envision, and the assault upon Missionary Ridge darned near impossible to adequately appreciate unless with a painstaking and dismounted trek.

Any visit to these battle sites can be much enhanced by using the excellent *Chickamauga: A Battlefield Guide with a Section on Chattanooga* by Steven E. Woodworth (Lincoln: University of Nebraska Press, 1999). But much valuable insight, and even military capability, can be gained by using the U.S. Army Combat Studies Institute September 1992 *Staff Ride Handbook for the Battle of Chickamauga, 18-20 September 1863,* authored by an array of four experts: Dr. William Glenn Robertson, Lt. Col. Edward P. Shanahan, Lt. Col. John Il Boxberger, and Maj. George E. Knapp.

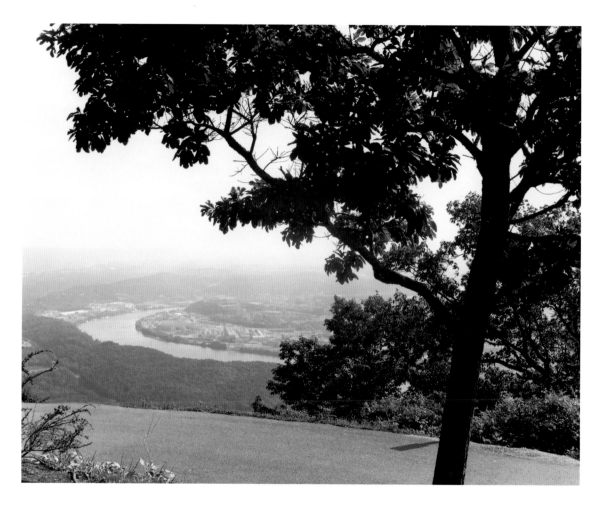

OVERLOOK
View of Tennessee River and Chattanooga.

MONUMENT
Iowa, near Craven House.

MONUMENT
Army of Tennessee Artillery.

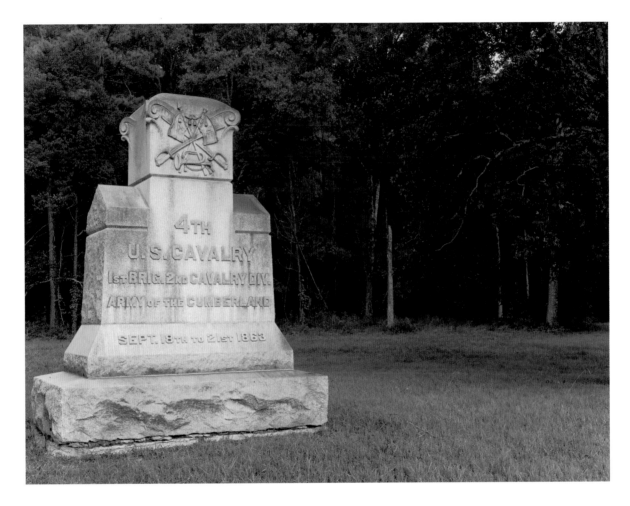

MONUMENT
Fourth U.S. Cavalry, Army of the Cumberland.

MONUMENT
Michigan Fourth Cavalry.

MONUMENT
Riderless Horse, First Wisconsin Cavalry.

FIELD OF MONUMENTS

Snodgrass Hill.

VIEW OF BATTLEFIELD
Union Right.

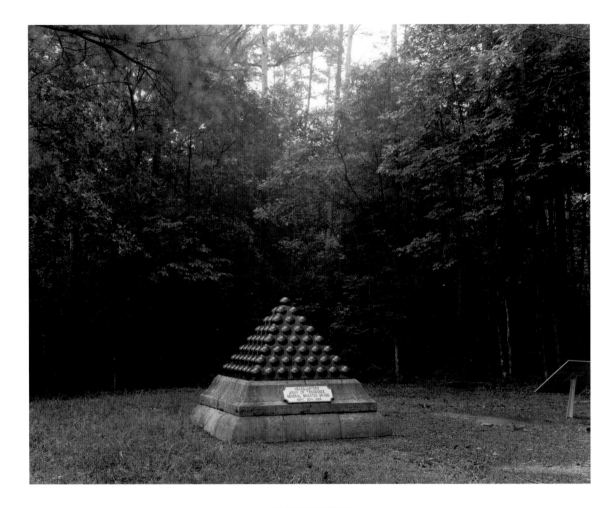

MONUMENT
Overview of the Headquarters of the Army of Tennessee.

VIEW OF BATTLEFIELD
Longstreet's Breakthrough.

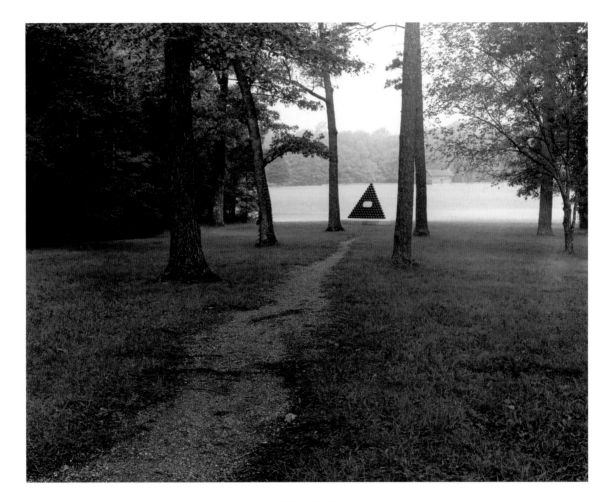

Kelly Field.

Trees and Reflections in Creek.

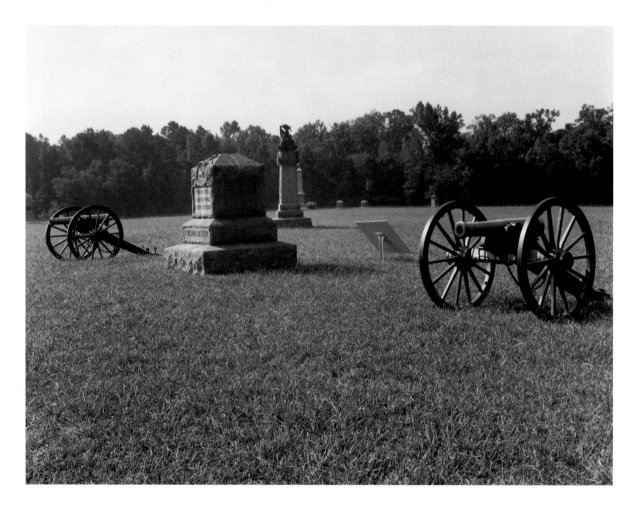

MONUMENT
Fifth Indiana Artillery.

III

Shiloh

III

Shiloh

THE BATTLE OF SHILOH has attracted much attention from scholars and from National Military Park visitors—who have made it *the* most visited battlefield park in the western theater. Shiloh was the first *really* big, costly battle of the war: the casualties equaled those of the Battle of Waterloo, and people on both sides were thoroughly jolted at the carnage and indecisive result.

Perhaps neither of the opposing presidents adequately apprehended the importance and significance of the western theater, but it may be illustrative that Jefferson Davis cared a lot about how things went therein, because he gave the command to his favorite general, Albert Sidney Johnston.

During the fall and winter of 1861–1862, the Federals were to much bolster their blue-clad forces. Johnston, who had impracticably elected to try a "cordon" defense—to attempt holding a four-hundred-mile line (east of the Mississippi River) with 57,500 troops—soon would be outnumbered by twice as many Federals. Despite the pretense of holding a line, Johnston had his forces concentrated in four key emplacements: 22,000 men under Maj. Gen. Leonidas Polk at Columbus, Kentucky; 5,000 troops divided between Forts Henry and Donelson, on the Tennessee and Cumberland Rivers, respectively; 24,500 troops at Bowling Green, Kentucky, under Maj. Gen. William J. Hardee; and 6,000 troops in eastern Kentucky under Maj. Gen. George B. Crittenden.

Sensing his peril, Johnston made frequent calls for more troops. President Davis and his principal advisors clearly knew about Johnston's overall numerical inferiority, but the Con-

federacy's dogged insistence on a uniformly potent defensive effort at *all* sectors prevented building Johnston's strength at the expense of lesser-threatened zones.

Things had begun to go awry in the West almost at the outset. A Confederate division under Maj. Gen. George Crittenden was routed near Somerset, Kentucky. The goat of the episode, nearsighted Brig. Gen. Felix K. Zollicoffer, rode headlong toward an enemy officer, who promptly killed him with a pistol shot. The relatively small battle at Somerset proved an ominous omen for Confederate ills in the West.

While Zollicoffer became something of a revered hero in death, nonetheless he was gone, and his superior Crittenden—a known abuser of alcohol—became a whipping boy of the critical press. President Davis rightly concluded that Johnston needed an able second-in-command—and readily available was Pierre Gustave T. Beauregard, whose abrasive personality and controversial, flamboyant behavior had made his presence close to Richmond less than welcome.

Early in February, however, Forts Henry and Donelson were threatened by combined army-naval forces under U. S. Grant. In hopes of holding the forts, the Confederates reinforced Johnston, but the new troops arrived too late. Now the Rebels were compelled to abandon their "cordon" effort and to fall back and reconcentrate—at Corinth, Mississippi, as *it*

turned out to be the northernmost point where this could be accomplished.

It also happened to be *the* major railroad junction of the entire western theater. There the Memphis and Charleston and the Mobile and Ohio crossed at a sixty-degree angle, giving the city the nickname "The Crossroads of the Confederacy." The prewar population had been only twelve hundred, but it was a busy enough place with many businesses, and it boasted three hotels.

Johnston gradually entrusted more and more authority to Beauregard, particularly in the planning of the next offensive maneuvers. Their choice would be forced by the Federals, who now began to give much more attention to things in the West. Before the fall of Donelson, and the resultant immediate fall of Nashville, Tennessee, too—a very important industrial city—Northern officials had been somewhat fixated on things in the East. Now, not only was tangible victory being achieved, but the yet unknown General Grant was beginning to draw attention to his capabilities. In turn, his superiors gave encouragement and support for further offensive operations in the West.

Confederate outposts encountered Yankee elements, the vanguard of a major thrust of force southward along the Tennessee River. The small Confederate detachments withdrew

inland, to form a forward observation post about three miles from a Methodist church called Shiloh. By the night of March 11, 57 Union transports had arrived at Savannah, Tennessee, carrying, by Confederate estimates, between 25,000 and 30,000 Yankee troops. U. S. Grant, assisted by his principal subordinate, William T. Sherman, was leading a major thrust deeper into Confederate territory. They were expecting soon to be bolstered by a significant reinforcement under Maj. Gen. Don Carlos Buell, which would be moving from the occupied city of Nashville. Sherman conducted the vanguard of Grant's force to the Pittsburg Landing area, where on March 17 the men began to spread out, encamp, and await the Union concentration in that vicinity.

The land on which Sherman's troops encamped, where in fact the Battle of Shiloh soon would be fought, was wilderness in places—uneven, thickly wooded, dense undergrowth—cut by sloughs, ridges, and deep ravines. Three-fourths of a mile from the landing were seven Indian mounds, which ranged from five to fifteen feet in height. Some thirty-six farms were scattered in the area, most of them with log cabins and between forty and eighty acres in size, planted with fields of cotton and corn along with some fruit orchards. About one mile from the landing was a junction, where the Pittsburg-Corinth Road connected with three other roads. The first, which led to Crump's Landing, was varyingly called the Hamburg-Purdy Road and the River Road. The second was the Eastern Corinth Road, and it swung inland to connect with the Bark Road. The Pittsburg-Corinth Road, also called the Western Corinth Road, ran parallel to the Eastern Corinth Road. Many other paths, worn by livestock and farm wagons, crisscrossed the terrain.

From mid-March through the first week of April, troops and materiel poured into the area. According to an official tally, 34,500 fighting men were present for duty on March 31, augmented by another 7,500 noncombatant support personnel: cooks, hospital staffers, teamsters, and so on. There would be, on the eve of the battle, some 45,000 men in the vicinity (exclusive of Maj. Gen. Lew Wallace's 7,000–man division, which was encamped somewhat to the north—about six miles downstream from what would become the battlefield—and would get lost trying haplessly to reach the fighting on the first day).

The Confederates knew, at least by March 24, that Grant's army, estimated at 50,000 strong, was concentrating near Pittsburg Landing. The Confederates believed Buell's army also to have 50,000 men and to be located at Columbia, Tennessee. If the Rebels moved rapidly enough to surprise the enemy, they might strike a hurtful blow against Grant's force. As many reinforcements as could be were rushed to the South-

ern commanders, swelling their army to in excess of 40,000 able-bodied men. (The actual strength on April 3 was 49,745, but some 7,956, or 16 percent, were on the sick list, and another 2,709 either were hospitalized or at home recuperating from the sicknesses that had been inflicted by the swampy surroundings and bad water.)

The Confederate army was a motley one, thoroughly western in nature: the overwhelming majority of the men being from Tennessee, Kentucky, Alabama, Mississippi, Arkansas, and Louisiana. There were numerous Zouave units dressed in outlandishly colorful outfits. The other uniforms, however, were rather nondescript: "Some wore uniforms, some half uniforms, some no uniforms at all," observed one Louisianan. The shoulder arms included squirrel rifles, percussion muskets, flintlocks, and shotguns. Only one third of the cavalrymen had any weapons at all. Most of the cannon in the artillery batteries were homemade, and some of the batteries would never have fired their pieces before going into the impending battle. Braxton Bragg, one of the four corps commanders, called the army "a mob."

In the end, although Beauregard clearly remained second in command, below Johnston, it was the Creole who devised the battle plan and organized the army. The First Corps, under Polk, was made up of two divisions of two brigades each, to-

taling 9,136 men. Bragg's Second Corps had two divisions, each with three brigades, and numbered 13,589 troops. Hardee's Army of Central Kentucky was now divided, with three brigades, numbering 6,789 men, forming the Third Corps under Hardee, and another three brigades, 6,439 strong, a fourth reserve corps, under the much-flawed Maj. Gen. George B. Crittenden.

The unequal distribution of troops was the obvious first flaw: Bragg had one-third of the total. To have divided into four corps was a ploy at deception of the enemy, because it was a norm for a corps to have as many as 20,000 men; hence, the army might be misestimated at twice its actual size. Grant, indeed, did subsequently estimate Confederate strength at 80,000 men, but there is no evidence that he based this on there having been four corps. What the army needed above all else was more coordination and a better staff structure. Bragg was named chief of staff, but because he kept command of his corps, he contributed but little at the staff level.

The Federals, contrary to a popularly held misinterpretation, did not possess any great advantage in firepower. A majority of the infantrymen had smoothbore muskets that had been altered to use percussion caps. A few entire regiments were equipped with new Enfield rifles, and some had old Aus-

trian rifles, but typically, any regiment might have a vexatious mix of shoulder arms. One Rebel opined after the battle that the Yankee arms had not been so good as to make them any prize to capture: they were cumbersomely hard to cock. In the artillery too, was there much to be desired. While it included some James conversion and Parrot rifles, nearly one-half of the field guns were smoothbore six-pounders and twelve-pounder howitzers.

Just as had the Confederates, many of the Unionists suffered mightily from the unhealthful conditions in the area. Huge numbers of men were ragged by diarrhea. Medicines were in scant supply, and only one hospital boat accompanied the supporting flotilla. One estimate held that nearly 17 percent of the command might legitimately be sent home because of ills that rendered them unable to withstand the rigors of a campaign.

Grant was not blessed with able principal subordinates. Indeed, Sherman was the only West Point–schooled professional officer who would be in command of any of the divisions by the time of the battle. The First Division was under a pompous political general from Illinois, John A. McClernand. The Second Division, under the ailing West Pointer Andrew Jackson Smith, would soon be taken over by still another nonprofessional, an Illinois lawyer, Brig. Gen. William H. L. Wallace. The Fourth Division was under another Illinois politician, the binge-drinking Stephen A. Hurlbut. The new Sixth Division was led by still another Illinois lawyer, Brig. Gen. Benjamin M. Prentiss.

The Federals were encamped in an orderly and efficient layout, but they had neither entrenchments nor field fortifications prepared. Their days were punctuated by regular drills and inspections. Otherwise the men spent their time writing letters, reading (usually week-old) Chicago newspapers, playing games such as horseshoes, and browsing at the very numerous subtlers' wagons. There was much gambling on and just after payday.

April opened with Johnston aware that the Yankee army was mostly at or near Pittsburg Landing, with a division at Crump's Landing, but uncertain of what the extent (if any) of their battle lines might be. Scouts reported seeing a few Federal transports and gunboats probing the Confederates past Yellow Creek. On April 2 reports came in that Buell's 30,000–man-strong army had passed over the Duck River and was pushing rapidly toward Savannah. The moment to strike seemed imminent. A battle plan modeled after Napoleon's at Waterloo was penned. Was it a good and viable plan? It *could* have been, but it was too complex for the extant attack force to execute effectively. The worst aspect of it was the intent for

the Confederate corps to assault in successive waves. That virtually guaranteed that eventually the lines and units from different corps would become intermingled—confusion, and hampered command and control, ultimately would be a stymieing factor.

The men were aroused at 4:00 A.M. on the third and had previously been instructed to depart Corinth within two hours. But the march intended for that day soon proved to be a botched affair. Eight o'clock arrived, with the generals still in briefing session. Given the apparent situation and conditions, a new start time was set for noon. That time came, and the streets of Corinth were filled with troops, wagons, and field guns, but even still the army did not commence to move. Hardee's corps had finally started out by 3:00 P.M., but some of the other commanders mistakenly arrived at the impression that the departure from Corinth was to be delayed for another whole day.

Once on the move, Hardee's men made good time, sometimes going very slowly and at others stepping at a double-quick time. It was burning hot, and there was much confusion, but they reached and passed the state line and continued marching on after darkness fell. About midnight they dropped down for the night, but rest was scant, for at 2:00 A.M. a torrential downpour of rain accompanied by hail began to fall.

When they resumed marching in the morning, a light rainfall was still coming down.

Johnston himself rode out early on the morning of April 4, still believing that the assault might commence sometime on that day. It quickly became evident that Beauregard's intended timetable had fallen apart. Much of the Confederate artillery had become mired in mud. Johnston asked one of his aides about the availability of axes to cut a new road but was informed that no axes had been made ready. At 5 P.M. Johnston, Beauregard, and Bragg held a conference, at which they concluded that there was no practicable choice but to reschedule the commence of battle for 8 A.M. the next morning.

The rain continued to fall during the night. Other nagging concerns caused various Rebel commanders to toy with still more options. Beauregard and Johnston both labored long into the night, aides sloshing back and forth with messages from one to the other. At some moment well past midnight, Johnston pressed Beauregard for acquiescence in possibly postponing the attack another whole day. Beauregard, however, responded that he thought time was of such importance that they had best attack at daylight. So the troops were formed into ranks at 3:00 A.M.

The Michie farm, an isolated and wretched little spread that was crossed by two roads, became, on the morning of

April 5, the focal point for Confederate operations. The farm-house itself already had been fitted out as a field hospital. Hardee's corps had encamped on the surrounding fields on the night of April 4. Now, at dawn, they commenced advancing two abreast. When three miles from the main Federal encampment, they received their first challenge. It was from an errant Confederate vedette, who, on being told he was holding up the vanguard of an entire corps moving to attack, only reluctantly agreed to let them pass. His ignorance of what was happening was but a minuscule omen: soon a massive traffic snarl began to form at Michie's farm, as Polk's and Bragg's commands merged.

Confusion continued to reign as the day dragged on, and still no battle could commence. At about 4:00 P.M. Beauregard visited Bragg at his headquarters, and the two agreed that the attack should be cancelled. Food seemed already to be running low. Beauregard had abandoned all hope for the surprise he had deemed essential: "Now they will be entrenched up to their eyes," he cried. Soldiers had been test-firing their muskets as the rains had ceased to ensure that the dampness had not rendered them inoperative. One whole regiment, the Texas Rangers, had let loose a concerted volley. Drums had been beat and bugles blown. A thunderous cheer had been given when a deer had been shot in front of the battle line. *Surely*

the Federals had to have heard all this racket. Johnston, however, was determined to launch an assault at the next dawn.

In the stillness of the ensuing night, within the Confederate camps, drums could be heard beating a tattoo. Furious, Beauregard dispatched an aide to order that the drum be silenced. The aide went out to investigate, but, flustered, he returned to report that the drum was within the Federal encampment.

What was the state of things within the Federal encampment? The soldiers there had little or no inkling of what was about to happen. Sherman had ordered that all camps should face west and have no more than twenty-two paces between regiments, but this largely had been ignored in favor of getting conveniently close to water supplies. While it had not yet become de rigueur at this early stage in the war regularly to entrench or to construct any field fortification, the indefensible condition of the camps was culpable, to say the least. Indeed, the experienced professional Maj. Gen. Charles F. Smith had counseled Grant and Sherman against using any entrenchments on the grounds that their absence would lure the Confederates out and, further, that to have such things might actually dull the men's fighting zeal. There were reports of some Rebels being in the area, but Sherman dismissed all

these as being nothing more than sightings of a Confederate reconnoitering party. Grant, meanwhile, continued to maintain his own headquarters at Savannah, where any day he anticipated Buell's arrival.

The first action came in Fraley Field, a forty-acre cotton field bisected by the west branch of Shiloh Creek. A Yankee patrol, four hundred men strong, according to later press reports, moved clumsily through the area near the Pittsburg-Corinth Road. Just beyond the road were Rebel vedettes moving through underbrush, and apparently they became aware of the nearby enemy patrol: they fired three quick shots and then rode off. The Federal patrol formed a five-company skirmish line and advanced into Fraley Field. Some seven hundred yards away stood Sterling A. M. Wood's brigade of Hardee's corps.

About 5:00 A.M. the Rebel outposts fired a single volley at the advancing Yankees. The Yankees closed to within two hundred yards, and Hardcastle's Mississippians opened fire upon them. For the next hour and fifteen minutes the opposing forces traded fire, each refusing to give ground. At first no one could really see much of the enemy save for the flashes of light made by firing rifles, but gradually came the nautical morning twilight. During a brief lull, the Yankee patrol com-

mander noticed what seemed to him to be a body of enemy cavalry trying to work its way around his left flank. This actually was an escort company, the Jefferson Mounted Rifles, searching for a route through the underbrush to bring up artillery. The Yankee patrol commander ordered his bugler to sound retreat.

Johnston and his staff had gathered around a small fire for a breakfast of coffee and crackers and were soon joined by several other generals, including Bragg, Hardee, and Beauregard. They heard the opening shots in Fraley Field. "The battle has opened gentlemen; it is too late to change our dispositions," Johnston said, and then asked that the exact time be noted: 5:14 A.M. Johnston mounted his steed, "Fire-eater," and turned to say to his staff: "Tonight we will water our horses in the Tennessee River."

The early reports suggested that the Yankees had been caught fully unprepared for the onslaught. "Can it be possible they are not aware of our presence?" a dumbfounded Johnston inquired of Beauregard. "It is scarcely possible they are laying a trap for us," was the Creole's cautious response.

The next exchange of gunfire occurred in a cotton field owned by Lewis Seay. The patrol scurrying away from Fraley Field met an advancing column from the Twenty-first Mis-

souri (Union). Arriving at the northwest corner of Seay's Field, they were fired at by Rebels along the fencerow on the southern field's southern edge. The Yankees fired back for a time, but when their colonel was wounded, they were ordered to retire.

This episode was, of course, just the harbinger of a general onslaught along a wide front, but that onslaught was cumbersomely slow in commencing. The Confederates frittered away a precious hour and a half, squandering much of the advantage they had gained by surprise. At last, however, did begin Hardee's first-in assault: 9,000 infantrymen augmented with artillery in a front of one and one-quarter miles. The Federals but briefly contested the Rebel advance and then began to fall back. Both sides fought furiously, suffering many casualties, until the Confederates overran the first of the encampments.

But the Confederates failed to continue steadily forward. Hardee's troops tended to incline toward the left, leaving an increasingly large space between their right and Lick Creek. Perceiving this, Johnston sent up James R. Chalmers's "Pensacola Brigade" to fill the gap. But Lick Creek turned sharply to the northeast, and the gap on the right was increased still more as the troops advanced. Some of the advancing Confederate elements were soon subjected to a galling infantry and artillery fire. They moved up their own guns for counter-battery firing.

Some very bitter and costly fighting ensued. One Ohio battery was caught in an exposed position in Spain Field. Within minutes, fifty-nine horses were killed. Two of the guns were overrun, but the Buckeyes managed to cut the dead animals from their harnesses and to escape with four pieces.

Now the scene shifted to the eastern portion of the Rea Field, where the Fifty-third Ohio had encamped. The men of this green unit were astonished and almost unbelieving that they were under a full-scale attack. Sherman and his staff rode into Rea Field at 7 A.M. The general still could not quite believe what was happening. But he apprehended quickly, shouting, "We are attacked!" and throwing up his hand as if to ward off a shot. His orderly fell dead, and Sherman himself took a bullet in the hand. Wrapping the wound with a handkerchief, he ordered the men to hold fast and rode off to secure reinforcements.

The Confederates haphazardly advanced, some crossing terrain that starkly favored the Northerners. The swampy thickets of Shiloh Branch proved to be extremely difficult to scramble through. Hardee's drive, which continued until mid-morning, quickly had degenerated into a simple frontal assault, rather than the right-wing wheeling motion that

Beauregard had planned. Still, the stark reality was that the Confederates had indeed achieved tactical surprise, and despite some squandering of that advantage, the Rebels kept doggedly advancing. At this point, it appeared that Johnston might well be headed toward a decisive victory.

But the Confederate high tide was near. The more than two-hour fight for control of Rea Field was a desperate and sanguinary struggle. The Confederates finally succeeded there, but near Shiloh Church, the Federal resistance stiffened. There, the Southerners attacked in uncoordinated fashion and suffered huge numbers of casualties. Sherman turned his personal attention to directing things in that sector, and he performed like a master. The strong resistance caused the Southern commanders to overreact and to commit additional troops here, the wrong flank in terms of the overall battle plan. Finally, by 10:00 A.M. the Confederates had succeeded in forcing Sherman's entire division to retreat. But the triumph was a Pyrrhic victory, for the Rebels had squandered much valuable time, and now many of them compounded the blunder by ceasing their advance so to rifle through the Northerners' abandoned tents and campsites.

This was an activity engaged in here and there and from time to time as excited Rebels swarmed into newly found campsites. Johnston himself had ridden into one about 9:00,

in company with his staff and escort. One of his lieutenants noticed a neatly ordered row of knapsacks and coats, all lain out for a morning inspection that had never taken place. Another officer approached Johnston to gleefully show him an armload of trophies. "None of that, sir; we are not here for plunder!" was Johnston's stern rebuke. But instantly he regretted being so harsh, and he picked up a tin cup and said: "Let this be my share of the spoils today." He would still be holding it in the afternoon, as he died.

At 10:00 the Confederates finally overran the Shiloh Church sector and commenced their next big drive forward. A bitter struggle subsequently ensued at the so-called crossroads, the intersection of the Pittsburg-Corinth and Purdy-Hamburg Roads. Again, however, as events unfolded, the Confederates overcommitted strength on their left flank, albeit achieving a stunning victory and inflicting literally staggering numbers of casualties, allowing the Union center and left to gain valuable time.

When Sherman and McClernand's Pittsburg-Corinth line had cracked in the late morning, they had hastily prepared to make a new stand to the north—in the vicinity of the Jones and Sowell Fields. By 11:30 A.M. Sherman and McClernand were able to unleash the first significant Union counteroffensive of the day. It was inhibited, however, by a lack of ammu-

nition; many of the units had not had time to replenish. The Confederates received reinforcements and moved in fierce counterattack.

But things began to snarl, and the Confederate advance stalled. Many men were simply exhausted. Many could not resist feasting on their finds within the abandoned Federal campsites. Many were short on, or out of, ammunition. Thus did the Federals received the gift of a window of opportunity to stabilize their lines and to bring up fresh troops. A 1,200–man force commanded by Brig. Gen. Benjamin M. Prentiss took position in a protruding and, as it would turn out, a crucial salient. Grant visited the spot and gave Prentiss the order to "hold at all hazards."

There was an eroded wagon trace, the old Purdy-Hamburg Stage Road, about two-thirds of a mile in length, along which the troops had aligned. Later, this road would be dubbed the "Sunken Road." It offered, of course, the cover of a ready-made entrenchment. Prentiss's troops were subsequently augmented with much more force: in the end the salient was held by some 10,200 infantry and eight artillery batteries with thirty-three guns. Theirs was the position that the Confederates would call the "Hornets' Nest." Again and again Rebels hurled themselves haplessly against this strong line, and the casualties began to pile up.

Confederate brigades long since had begun to intermingle. There was much confusion. In one bizarre episode, the Thirteenth Arkansas and the Fourth Louisiana, each mistaking the other for enemy, exchanged "friendly fire"—which assuredly is the *most unfriendly* kind there is. The self-destruction might have gone on longer, but a woman in a sunbonnet appeared, seemingly out of nowhere, and wandered between the lines.

But hours slipped by while the Confederates formed and reformed and assaulted, ultimately a total of eight times. The final attack was launched at 3:30 P.M. Probably some 10,000 Confederates were thrown into the Hornets' Nest fight. A careful student of the episode places their casualties at about 2,400, or 24 percent. Flanking movements probably could have produced the same outcome with less loss, but the Confederates consistently tended in this battle to try brute strength over finesse. Of course, too, by more modern standards, the general advance should never have been halted in other sectors simply to await reduction of the Hornets' Nest, but not to leave any major pocket of resistance at one's rear was the norm then.

Johnston's uniform was torn by minié balls in several places, then the heel of his boot was shot away. Pointing to the boot, Johnston said to his aide, Tennessee governor Isham G.

Harris, "Governor, they came very near putting me hors de combat in that charge." "Are you wounded?" Harris asked, but Johnston said not. So Harris rode off to deliver one of Johnston's orders.

Two staff officers remained with Johnston. One of them noticed blood dripping from the heel of Johnston's boot. "General, you are wounded," he said, "and we had better go down under the hill, where we will not be exposed to the bullets." But Johnston replied emphatically: "No; Hardee's fire is very heavy. We will go where the firing is heaviest." As Johnston was turning his horse, the other officer cried out: "General, your horse is wounded." "Yes," replied Johnston, "and his master too."

Harris returned, and as he was giving a brief report, Johnston began to swirl. He was caught by the two staff officers, one of them again asking, "General, are you wounded?" "Yes," he said, "and I fear seriously." Harris led Johnston's horse to a ravine east of the Hamburg-Savannah Road, about one hundred yards south of Sarah Bell's farm. The officers set Johnston on the ground, leaning against a tree, and frantically began tearing at his clothing, searching in vain for the wound. No one apprehended the seriousness of the profuse bleeding in Johnston's boot. The general had dispatched his personal physician earlier to care for the wounded, which had included many Federals. Within thirty minutes, Johnston bled to death.

Governor Harris took a dispatch to Beauregard informing him of the situation. Beauregard and his staff had moved to "Headquarters No. 3," a clump of trees at the crossroads. Although suffering from acute laryngitis, Beauregard had been keeping abreast of the unfolding battle and had a good grasp of the overall tactical situation. He had been in virtual command of two-thirds of the army since midmorning. Upon hearing of Johnston's death, Beauregard said nothing at first. Then he replied, "Well, Governor, everything else is progressing well, is it not?" He sent messages to the corps commanders informing them of Johnston's death but strictured that they should keep this news from the troops and continue pressing forward.

The Hornets' Nest was finally taken after a barrage from fifty-three artillery pieces, firing at a range of five hundred yards. The Federals managed to offer some potent return fire. The effect of the massed Confederate pieces was the final scale-tipper, but in truth, the Yankee salient was already beginning to crumble even before the barrage began. They had held out for six hours, buying the Federal army time and turning the tide in Grant's favor. About 2,200 men were taken captive.

Buell arrived at Pittsburg Landing about 1:00 P.M. At 2:00 he and Grant met aboard the *Tigress*. Buell asked what preparations had been made for a retreat, and Grant replied, "I have not yet despaired of whipping them, general."

But by 4:00 P.M. the situation around Pittsburg Landing seemed grim. The Federals formed a makeshift perimeter about a mile and a half long to make their final stand of the day. The final Confederate assault came at 6:00.

Even as the Confederates commenced that assault, Grant denied the desperation of the situation and stated that the enemy's momentum had "spent its force." Such optimism in the face of stark realities is notable: 7,000 Federals had been killed or wounded, and another 3,000 had been captured. At least 10,000 more were in confused disarray and not at all malleable about getting back into fighting ranks. But Grant knew as night began to fall that time had swung to his advantage. He could feel sure that at least two new divisions would arrive during the night: these would be a fresh 11,000 men to be augmented by the balance of Buell's arriving force.

A group of Federal officers was standing around a campfire near dusk, when James B. McPherson rode up. Grant asked him: "Well, Mac, how goes it?" McPherson gloomily replied that at least one third of the army was inoperative and nearly all the rest of it was disheartened. Then McPherson asked if preparations should be made for a retreat. "Retreat?" was Grant's quick and terse response: "No! I propose to attack at daylight and whip them."

Shortly before sunset, from his headquarters near Shiloh Church, Beauregard dispatched staff officers to call off any further fighting for the day. A host of historians have argued that Beauregard was insufficiently informed and out of appropriate proximity to make such a call. Some historians even have insisted that, given the realities of the moment, a further assault should have been ordered, and even—though extremely rare by Civil War standards—a night attack would have been possible. The sun set that day at 6:10 P.M. The Hornets' Nest fell sometime between 5:30 and 5:45, although sporadic firing continued until 6:00.

The fact is, the terrain over which the Confederates would have had to advance to get to Grant was *quite* forbidding. It is unlikely that a night attack could have met with success. Grant's line was, in fact, stronger than had been the Hornets' Nest. The Confederate troops were exhausted, most of them low on or out of ammunition, and units were in entangled disarray. Indeed, some units had begun to withdraw even before the order to do so arrived.

Although Beauregard spent the evening of April 6 in Sherman's tent, conferring with his corps commanders, no orders nor plans were prepared for the morning. Plundering of the Union camps was rampant, although many of the sites had been ravaged a dozen times already. Indeed, a Louisiana surgeon estimated that by midnight nearly one-half of the army was already on the road going back to Corinth, "loaded with belts, sashes, swords, officer's uniforms, Yankee letters, daguerreotypes of Yankee sweethearts [and some were] prostrate with Cincinnati whiskey—some enlivened with Philadelphia claret."

Others who tried to sleep, or at least rest, were much harried by the thunderous booms of fire from the gunboats. The incoming rounds caused little real damage, but many of the men cringed behind trees throughout the night, and very few got any peaceful rest. Things became even more miserable when, at 10:00 P.M., a rainstorm commenced; it turned into torrents by midnight. There were numberless flashes of lightning followed by nerve-shattering claps of thunder. And lastly, another element of gloom: the moans of the wounded could be heard incessantly. The Rebels had sustained somewhere around 8,000 casualties.

Not *all* of the Rebel commanders were remiss during this night. Col. Nathan Bedford Forrest had a patrol of men disguised in Yankee uniform coats to infiltrate the enemy lines and reconnoiter near the Tennessee River. They returned to report that the blue-clads were being heavily reinforced. Forrest tried to get word to various of the Confederate generals but all to no avail. Forrest bluntly warned that the Rebels should either immediately attack or start evacuating, because if they did not they would surely be "whipped like hell before ten o'clock tomorrow." He spoke with Chalmers, and then Hardee, but all he got were instructions to maintain a strong picket.

Grant was determined to launch a counterattack at dawn. He tried to get some sleep, but his ankle injury plagued him, as did the screams of the wounded. He decided to leave his cabin and to go outside and lean up against a tree while the rain came down. Sherman came to see him at midnight and found the army chief with his hat pulled down over his face, his collar turned up, a dimly lit lantern in one of his hands, and him puffing on a cigar. "Well, Grant, we've had the devil's own day, haven't we?" And Grant replied, "Yes. Lick 'em tomorrow, though."

Buell had brought up approximately 8,000 men from his army; and Lew Wallace's 7,000, although on the march all the previous day, were far more ready for battle than the combat-fatigued Confederates. Grant's fresh strength stood at three divisions and one additional brigade.

The second day's fighting commenced in the Cloud and Wicker Fields. In Cloud Field, just beyond Hurlbut's old head-quarters, stood the advanced Confederate pickets. When the advancing Yankee skirmishers uncovered the picket, the Rebels fired and then ran as "quickly as their legs would carry them," noted an Indiana trooper. At Wicker Field the Confederates offered stiffer resistance: concerted infantry fire augmented by artillery. A spirited half hour engagement ensued.

Over on the Confederate right, the troops had begun rous-ing and forming at about 4:00 A.M. Shortly before daylight the skirmishers engaged. Sporadic fighting dragged on for many hours, and by 9:00 A.M., Hardee had received orders from Beauregard to attack. His troops did, but they met stiff resistance at the Sunken Road, and not long afterward, the Rebels began to break and run, and the Yankees gave chase. "It was a wild pursuit, for a long distance, over rough coun-try. We loaded and fired as fast as we ran," recalled one Yan-kee lieutenant. Confederate artillery was able to pour some

sixty rounds into the pursuing blue-clad force, but could only blunt, not check, its onslaught.

Bell's Field would prove to be a crucial piece of real estate. There was fierce and confused fighting, and finally some ele-ments of the Federals were repulsed. Hardee—himself slightly wounded in the arm, and his uniform already ripped in sev-eral places by bullets—now personally led a counterattack. The Confederates tried to get reinforcements, and some did come, but men in other units simply refused to budge.

By late morning, the main action had begun to shift toward the center of the battlefield, along the Sunken Road. There was an intense artillery duel. Cannoneers in some Federal batter-ies eventually collapsed from exhaustion, and infantrymen volunteered to keep the guns in action. The brave Rebel horse-men of Morgan's Kentucky Squadron charged across Duncan Field, coming to within thirty yards of the Federal line, but then had to yield to the withering fire and fall back. One Ken-tuckian remarked, "Many an empty saddle was seen."

Beauregard had begun the day in a somewhat delusional mood of buoyancy. His army was an organizational mess, it had sustained some 8,000 casualties, and many were already well on their way back to Corinth. But when he heard the first cracks of opening musketry fire, he calmly remarked, "The

enemy must be near. We will mount, gentlemen, and go to the front." He shouted to one of the Louisiana brigades as he passed them, "Men, the day is ours, you are fighting a whipped army!" This mood was reinforced later when one of the men in the Fourth Louisiana discovered a fife. It happened that the man had been a fifer in the regular army during the Mexican War. So, he was able to pick the instrument up and begin to play "Dixie." The shrill notes could be heard for some distance, and it prompted a number of rousing cheers. Beauregard rode up and down the line shouting, "The day is ours! One more charge and we have the victory!"

How false was the prediction: the Confederates gradually were driven back all along their lines. Here and there a firm stand was made, but all were inexorably engulfed. By 1:30 P.M., a big fight had shaped up for control of the Water Oaks Pond sector. Here, however, at a crucial moment, came the vanguard of Buell's fresh army. By 2:30 the Federals had retaken the Purdy-Hamburg Road.

The Confederates were keenly aware of the fresh and renewed-in-strength foes whom they faced, and this knowledge further depressed their spirits. As Mississippi Private A. H. Mecklin put it, he "began to have doubts as to the issue [outcome] of this contest. I knew that the enemy were reinforced and stoutly."

On the Confederate left, Bragg tried to establish a new line north of the Shiloh Church. Beauregard tried to scrounge reinforcements for it. But those available soon proved to be too scant. Col. Thomas Jordan, Beauregard's chief of staff also serving as adjutant general for the army, asked Beauregard, "General, do you not think our troops in the condition of a lump of sugar thoroughly soaked with water, but yet preserving its original shape, though ready to dissolve." The Creole, sadly now inclined to accept the inevitable, said, "I intend to withdraw in a few moments." Preparations were begun to make the withdrawal as orderly as possible under the circumstances.

At 3:30 P.M. the final Confederate defense line was pieced together just south of Shiloh Branch. Somewhere between 1,500 and 2,000 infantrymen, augmented with twelve to fifteen guns, made a brave stand, and at 4:00, they even tried a plucky assault, which induced the advancing Yankees to scurry rearward. At 5:00 the Southern infantry withdrew and were followed but gingerly by an anemic Yankee advance. The chase was soon called off, and the Battle of Shiloh was over.

There was still a full hour of daylight left when Grant elected to discontinue the pursuit. He had three good reasons for doing so. First, the men were extremely tired. Second, he

had some suspicion, falsely, as it proved, that there was still some significant enemy force near the front that might renew a counterassault. And lastly, the command situation between himself and Buell was sufficiently hazy that he was constrained from given the latter any direct order. Too, Halleck had sent him an order to "avoid another battle if you can," but that was a moot thing, because further pursuit would simply have been part of the same battle.

The Confederate army was in pretty bad shape. "Our condition is horrible," Bragg sent word to Beauregard at 7:30 A.M. on April 8. "Troops utterly disorganized and demoralized. Road almost impassable. . . . Our artillery is being left all along the road by its officers; indeed, I find but few officers with their men." Beauregard did what little he could to cope with the situation. He sent word to the Corinth quartermaster that all unattached animals should be sent at once to help bring in wagons and guns, two-thirds of them to go via the Monterey Road and the other third by way of the Ridge Road. Chalmers, at Monterey, was ordered to detach work parties from his cavalry force to obstruct Hamburg Road.

The suffering wounded were, by and large, left in homes along the way, but those who were not wounded suffered mightily too. The roads were badly churned and eventually became nearly impassable. One private later wrote to his mother, "I am not exaggerating when I inform you that all the way the mud was knee deep, and we were obliged to wade several streams which were waist deep." A sergeant in the Seventeenth Louisiana wrote his wife that "the trip back to Corinth used me up worse than the battle."

On April 8 Beauregard sent an officer under a flag of truce with a message to Grant asking that details be allowed to pass through the lines in order to bury the Southern dead. Grant wrote in reply: "Owing to the warmth of the weather I deemed it advisable to have all the dead of both parties buried immediately. Heavy details were made for this purpose, and it was accomplished." This was not quite true; the job was not completed until April 11. And apparently some bodies were not found, for the Southerners tallied their dead at 1,723, while 1,624 were gathered up and buried in communal trenches, according to one Union soldier, "with as little concern as I would bury a dog."

The early reports indicated Union casualties to be some 7,000; it turned out to be over 13,000. The Confederates lost about 10,000 men. So Shiloh claimed in killed and wounded nearly twice the numbers at Manassas, Wilson's Creek, Fort

Donelson, and Pea Ridge combined. Indeed, these two days of warfare had claimed more than the casualties in all of America's previous wars combined.

There are many good books about Shiloh. Probably the best modern single-volume account is Larry J. Daniel's *Shiloh: The Battle That Changed the Civil War* (New York: Simon and Schuster, 1997).

For the preservation of the Shiloh battlefield, it was fortunate that the area did not undergo widespread agricultural or industrial development after the war. When the movement to establish the park was begun, the battlefield was little changed, and the land could be had at a price the federal government was willing to pay.

The movement to make Shiloh battlefield a National Military Park was the direct result of pressure from Union veterans of the western armies, who desired to have the scene of one of their most memorable battles acquired and preserved by the federal government. Chickamauga-Chattanooga and Antietam had been established as National Military Parks in 1890, and plans for the creation of the Gettysburg National Military Park already were under way.

The Shiloh National Cemetery had been established in 1866, but aside from that ten-acre tract, the historic ground around Pittsburg Landing was in private ownership. The inception of the Shiloh National Military Park movement dates from 1893, when a party of Union veterans visited the area, at which time they were concerned to learn from the superintendent of the cemetery that some remains of Union dead were being uncovered each year by farmers plowing their fields or unearthed in the process of road construction. Making their return, as passengers aboard the river steamer *W. P. Nesbitt,* the group held a formal meeting and established the Shiloh Battlefield Association. This was the spark that further kindled into a roaring heat and was responsible for the enactment of a law just a bit more than one year later, creating the Shiloh National Military Park.

The group behind founding the park, exclusively Union men, got much help from the very well organized and rather prosperous veterans' organizations in the North, but it also benefited from the men's various connections with potent members of the federal government. Gen. John A. McClernand, who served as president of the Shiloh Battlefield Association, was a powerful politician in Illinois. He had as his principal associates other prominent, well-known, and well-connected individuals: Gen. Benjamin M. Prentiss of Missouri (commander of the ill-fated Hornets' Nest), Gen. Lew Wallace of Indiana (author of *Ben Hur*), Gen. D. C. Buell of

Kentucky, ex-governor Thayer of Nebraska, and Gen. Andrew Hickenlooper of Ohio.

It was not long before ex-Confederates became interested in helping to promote the park at Shiloh, and some of them were quite prominent, too. These included Senator Isham G. Harris of Tennessee, Col. William Preston Johnston of Louisiana (Albert Sidney's son), Gen. Stephen D. Lee of Mississippi, and Gen. Basil Duke of Kentucky.

Aid was secured from the Society of the Army of the Tennessee, which received a presentation from the park group at its twentieth-fifth reunion, in Chicago, on September 12–13, 1893. This society passed a resolution, committing itself to work with veterans from both North and South to agitate for the establishment of Shiloh Military Park. Representatives from the group worked throughout the next year to see that an appropriate bill be introduced in the Congress. The most active operant was E. T. Lee, the secretary of the Shiloh Battlefield Association, who, during the spring of 1894, visited the battle area, and acting in the name of the association, took options on 2,300 acres of land.

The most powerful and largest of the Union veterans' associations, the Grand Army of the Republic, reviewed and endorsed the proposed bill.

Shortly after its organization, the Shiloh Battlefield Association had met at Indianapolis and there formed a committee of members of the United States House and Senate who were known to favor creation of the park. In the Senate, these included John Sherman of Ohio (William Tecumseh's brother), Col. William F. Vilas of Wisconsin, and Isham G. Harris of Tennessee (Civil War–time governor of that state and member of Gen. Albert Sidney Johnston's staff). From the House, there were Col. D. B. Henderson of Iowa, Gen. John C. Black of Illinois, and the famous Confederate cavalryman Gen. Joseph Wheeler of Alabama.

The bill was introduced into the House on December 5, 1894, where it passed; it was sent to the Senate, which passed it on December 19. President Grover Cleveland signed it into law on December 27.

Strangely, some opposition emanated from the eastern press, where the feeling existed that too many national military parks were being established. But this opposition was neither very strong nor tenacious: Congressman Henderson, who had authored the Shiloh bill, mused that when the proponents of the national military park "pitched into" the opposition, "the unfriendly critics hauled down their battle flag."

The War Department too, however, had become cool to the proliferation of national military parks, and resistance from that quarter was not so easily stilled. The department

urged that only a small portion of the battle area, perhaps a scant twenty-five acres, be set aside for memorial purposes. This attitude was particularly strongly held by Maj. George B. Davis, who at the time of the park's establishment was the chairman of the Commission for the Publication of the *War of the Rebellion; Official Records of the Union and Confederate Armies.* Davis long continued to agitate, even after he was promoted to brigadier general and was appointed judge advocate general of the War Department.

A hearing was held before the congressional Subcommittee on Parks and the Committee on Military Affairs in April 1902. Davis made a statement, in which he traced the background of the military park movement and summarized his own attitude:

> Congress authorized the establishment of a park at Gettysburg some years after the one at Chickamauga was authorized. The project at Chickamauga contemplated the acquisition of a large area, with a view to preserving the battlefields in the vicinity of Chattanooga in the same condition, substantially, in which they were when the battles were fought. It involved, of course, a considerable expenditure of money. That expenditure has been wisely made, and, in addition to a valuable historic park, the United States has acquired a ground for the purpose of encampment and maneuver which is worth all the money which has been expended thereon. My belief was then—it has not been changed—that this was the proper thing for the United States to do for historical purposes, in order that coming generations might see what a battlefield was. My idea was that it was proper to acquire one large historic field in the West and one in the East, and that there the acquisition of areas should cease. That view has not been changed, that the Government should desist from the further acquisition of large tracts of land. . . .
>
> The Shiloh field is very inaccessible; indeed, you can not buy a ticket to the Shiloh battlefield. You can get within 20 miles of it, and then you must hire a team to reach the field. For this reason it is less convenient than Chattanooga, for example, for purpose of instruction. It is a flat, uninteresting field, without any striking natural features. Antietam and Gettysburg in the East and Chickamauga in the West would answer all the needs of technical military instruction at the present time, and would also meet the needs of the War College.

Well, with opposition such as that, it is a wonder that the park commission was unfazed. The commission simply plunged onward; soon most of the park land had been acquired, and rapid development was under way. Davis, to his

credit, did cooperate with the park development once it became apparent that his opposition was to come to naught.

Popular attitude was very favorable toward development of the park, and the various states, though only Northern ones at first, appropriated funds to erect monuments to their troops who had fought at Shiloh. By 1901, five state monuments had been authorized, as well as appropriate markers, at a total cost of nearly $100,000. But the southern states gradually began to be interested in the Shiloh National Military Park, and by 1920 twelve states, some Northern and some Southern, had erected a total of 117 memorials to their Shiloh participants.

By 1913, 3,500 acres had been acquired for the park. Today, the park's nearly 4,000 acres includes Pittsburg Landing as well as all of the scenes of the heaviest fighting.

The veterans flocked to the battlefield for many years, often having functions of various kinds thereon. Thanks to their assistance, the battle lines and positions of the camps were established with considerable accuracy. The public, on the other hand, tended not to visit the park in any significant numbers during its early years, owing to its vexatious inaccessibility. By the turn of the century, those folk who did make the difficult journey found over 200 battle markers and 26 cannon, each marking a battery position. The fields and woods surrounding the battleground also had been returned to their 1862 appearance. By 1908 an additional 400 markers and 225 guns were in place. Indeed, Shiloh had become the single best marked of the battlefields in the West.

For a good many years, it continued to be a rather difficult business to visit the park. The dirt roads in the vicinity were very poor, choked with dust in dry weather and especially difficult to traverse in wet seasons. Railroads did pass through Selmer, Tennessee, thirteen miles west of the park, and through Corinth, Mississippi, twenty-two miles south, but they were of little help to the would-be tourist. The Tennessee River remained for years the principle way to get to Shiloh battlefield. The St. Louis and Tennessee River Packet Company ran excursions for two-hour visits at the park. Local citizens typically would hire out their hacks or wagons and guide tours for twenty-five cents per person, but they typically were not very knowledgeable. If Maj. D. W. Reed, the park historian, happened to be available—which he frequently was—to give a well-informed tour, the visitor would profit; otherwise, for many years there were no other good guides to be had.

Shiloh continued to be mainly a major attraction for the Confederates who had fought there, if they could manage a visit, and for Northern veterans and their families from Illinois, Iowa, Indiana, Ohio, Missouri, Michigan, and Wiscon-

sin—for from those states had come virtually all of the Union participants of the battle.

A disastrous cyclone came in 1909, killing seven people and wreaking terrible destruction upon the park's buildings and woods. The Iowa monument and the Ninth Illinois Infantry marker were destroyed, and at least half of the headstones in the cemetery were broken or knocked over. Many of the records of the battlefield commission had been stored in a building that was destroyed, and they were lost.

Rebuilding came fast. By July 1910, the commission reported that "all the buildings, except the Commission's quarters and office, have been restored, and work was begun June 20 on a new office building." In the years that followed, physical improvement of the Shiloh National Military Park continued at an impressive pace. By 1933, when the National Park Service took over administration from the War Department, all the cyclone damage had been repaired, and a new park pavilion and residences for park staff had been constructed. A new road soon was built, which brought automobile traffic to Shiloh. More memorial dedications ensued. Ohio's monument, which had been the first, in 1903, ultimately was joined by those from Indiana, Pennsylvania, Illinois, Tennessee, Wisconsin, Iowa, Alabama, Minnesota, Arkansas, Louisiana, and Michigan. On May 17, 1917, there had occurred the largest dedication. Then, some 15,000 persons turned out to watch the official donation ceremony by the United Daughters of the Confederacy of their Confederate Memorial.

The automobile age came to Shiloh in the period following 1910. The river steamers would continue to be the major conduit for the mass of visitors, but gradually, more and better roads were constructed. In 1914, the Corinth, Shiloh and Savannah Turnpike Company, which the state of Tennessee had chartered, built a toll road from the Mississippi-Tennessee state line northward to the park. This road, an all-weather gravel turnpike, began immediately to vastly increase the park's vehicular traffic.

Annual reunions of various veterans organizations were held at the park for very many years. The most notable of these groups was the Association of the Battle of Shiloh Survivors, which began a series of yearly conclaves in 1907. The 1912 fiftieth anniversary of the battle attracted three hundred members of the Hornets' Nest Brigade—a rather unusual veteran's group made up of Northern survivors of that defensive stand. In 1920 occurred the first "Shiloh Sing"—a four- to six-hour-long performance by vocal groups from throughout the South—beginning an annual tradition that continues today and attracts the largest crowds of the year to the park.

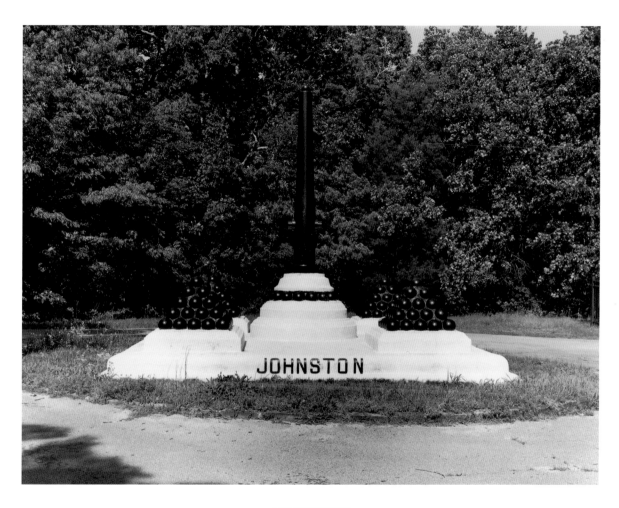

MONUMENT
Gen. Albert Sidney Johnston, C.S.A.

101

Dead tree. Site of General Johnston's Death.

The Bloody Pond.

Sunlight, Sky, and Trees near the Bloody Pond.

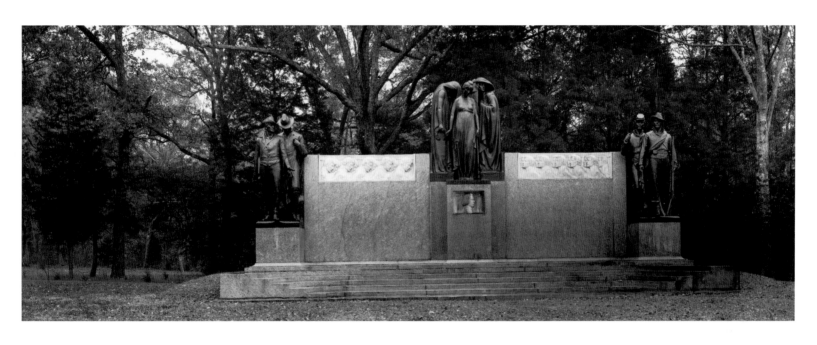

MONUMENT
Confederate Memorial.

Site of Confederate Cemetery.

The Hornets' Nest and Sunken Road.

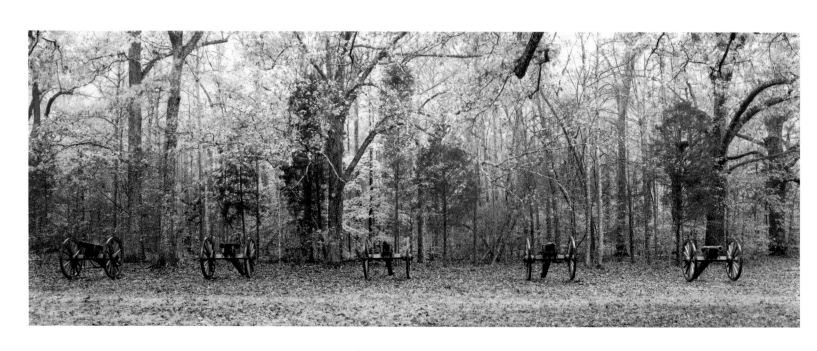

CANNON DISPLAY
Ruggles's Battery.

VIEW OF BATTLEFIELD
Oak and Field, Confederate Lines.

Pittsburg Landing, Union Cemetery, and Tennessee River.

IV

Antietam

IV

Antietam

CAPITALIZING UPON THE Confederate success in the August 29–30, 1862, Second Battle of Bull Run (which the Rebels called Second Manassas), the Army of Northern Virginia thrust into Maryland. Fording the Potomac River on September 4, Robert E. Lee's ragged Southern soldiers, many of them barefoot, marched with high hopes, their regimental bands playing "Maryland! My Maryland!"

> The despot's heel is on thy shore, Maryland!
> His torch is at thy temple door, Maryland!
> Avenge the patriotic gore
> That flecked the streets of Baltimore,
> And be the battle-queen of yore,
> Maryland, my Maryland!

> Come, for thy shield is bright and strong, Maryland!
> Come, for thy dalliance does thee wrong, Maryland!
> Come to thine own heroic throng,
> Stalking with Liberty along,
> And chant thy dauntless slogan-song,
> Maryland, my Maryland!

This Confederate incursion into enemy territory, however, was intended to be a raid, not an invasion, for Lee expected to have to return to Virginia at least by the ensuing winter. He wished to feed on the enemy's country, while also protecting the harvest in Virginia. Further, there was much expectation that many Marylanders might be Southern sympathizers and possibly a good number of the able-bodied young men

among them even might be induced to join the Confederate army. If a battle were fought, and in truth Lee did *not* wish to precipitate any major engagement, a Rebel victory on Northern soil well might bring European diplomatic recognition of the Confederacy. It just might force the North to accept terms.

The Northern high command was, of course, well aware of Lee's early movements. But there was some uncertainty and more than a little disarray in Washington following the debacle at Second Bull Run. Another change in top field command seemed in order. Gen. John Pope blamed his recent defeat on the "unsoldierly and dangerous conduct" of his faithless subordinates, who, he claimed—with more than a little justification—were more loyal to George B. McClellan than to him. "Pope did well," President Abraham Lincoln noted, "but there was an army prejudice against him, and it was necessary that he should leave." Pope was sent to Minnesota to deal with the Great Sioux Uprising. But now whom to place in the main field command? There seemed little else to do than to restore the popular McClellan to full command of main eastern theater forces, despite Lincoln's serious doubts about the man admirers called "Little Mac" or "the Young Napoleon." McClellan's detractors, and there were many, called him "the Young McNapoleon."

In Frederick, Maryland (the town where, incidentally, occurred the perhaps apocryphal incident in which the elderly Barbara Frietchie confronted and stoutly denounced Stonewall Jackson's rebels, which later was immortalized in John Greenleaf Whittier's poetry: "Shoot if you must this old gray head, but spare my country's flag, she said") Lee formulated his plans. He needed at least a rudimentary line of communications to bring him ammunition and other basic supplies. For this he intended to use a wagon route from Winchester, Virginia, through Harpers Ferry into Maryland, but a significantly large Federal garrison held Harpers Ferry. Jackson's corps would be diverted to take that place, thus dividing the Confederate army and leaving it precariously vulnerable to being defeated in detail.

Worse, a copy of Special Order Number 191, detailing the separate movements, fell into Union hands. For some never-explained reason, it was wrapped around three cigars and then lost. The precious bundle was spotted lying in a clump of grass by Yankee Pvt. Barton W. Mitchell of the Twenty-seventh Indiana, part of McClellan's advanced skirmishers. Barton showed the document to Sgt. John M. Bloss. "As I read," Bloss reported in one of the war's great understatements, "each line became more interesting." Within forty-five minutes of its being found, the paper swished through the hands of all men

in the chain of command upward to McClellan, who "gave vent to demonstrations of joy." Orderlies and staff officers went "flying in all directions."

"Now I know what to do!" McClellan gleefully chortled. The famous lost order revealed to him that Lee's army was beyond South Mountain now divided into four widely separated parts. "Here is a paper," McClellan said to his subordinate generals that evening, "with which if I cannot whip Bobbie Lee, I will be willing to go home." "Castiglione will be nothing to it," boasted McClellan, referring to Napoleon's 1796 victory over an Austrian general who had incautiously divided his forces. Stephen Sears observed, however, in his impressive and readable but harshly critical biography of McClellan that "perhaps McClellan did not recall that it was Napoleon's rapid and well-timed marches that had made the victory possible." Lee learned of the lost order within twenty-four hours of the misfortune. And on that very day, September 14, 1862, occurred the Battle of South Mountain. The passes through South Mountain were vital for the Army of Northern Virginia's supply. Lee's army was widely scattered and west of the mountains.

The Federal army advanced in two wings. The left, under Maj. Gen. William B. Franklin, headed in the direction of Harpers Ferry, aiming to interdict the Confederates trying to get at that place. Franklin's men moved into the pass and fought the surprised Southerners in the secondary Battle of Crampton's Gap. McClellan's right wing, some thirty thousand men strong, marched on the National Road, which passed through the mountain at Turner's Gap. A mile to the south a smaller road passed through the mountain at Fox's Gap.

Only one Confederate brigade was guarding Turner's Gap. The Battle of South Mountain opened with Union cavalry engaging this lone Confederate brigade. But as the fighting escalated, both sides gradually brought up reinforcements. There was jumbled and confused combat, but the Federals at last pushed through the gap. Then, however, their attack stalled, and a two-hour lull ensued. During that fortunate respite, the Confederates were able to bolster their strength, many units racing along dust-choked roads, some of them scrambling up the mountainside to extend the defensive array.

Late in the afternoon the Federals at last assaulted. The fighting was fierce. Still more Confederate reinforcements came up and bolstered the stubborn resistance. The battle raged on into the evening. By 10:00 P.M. the Federals had seized control of Turner's Gap. At midnight the Confederates withdrew and marched to Sharpsburg, where Lee would reconcentrate along Antietam Creek. The Federals had lost 325 killed, 1,403 wounded, and 85 missing, a total of 1,813. The Confederates suffered 325 killed, 1,560 wounded, and 800

missing. But though they had lost the battle, the fighting had bought a critical twenty-four hours for the Southern army, and it saved its supply train from capture.

On the next day, September 15, most fortuitously for the Confederates, Harpers Ferry fell. Jackson's corps snatched quite a prize: they seized 73 pieces of artillery, 13,000 small arms, 200 wagons, and took 12,500 prisoners. This was the largest single surrender of U.S. troops during the entire war. Jackson achieved this success not a moment too soon; following the Federal success at the South Mountain gaps, the Unionists were diverting more units to oppose the attackers at Harpers Ferry. Jackson now began hurrying as many of his troops as practicable up the road toward Lee and the main Rebel army.

Even on September 16, when McClellan could have attacked before any of Jackson's men arrived, "Little Mac" chose further to delay, and by the middle of that day, the first of Stonewall Jackson's men had begun arriving. More came up all during the rest of the day and in the evening, two divisions managing to get there by dawn of the next day. Three and one-half days had passed since the finding of the lost order.

Making ready to attack, the Union troops formed just to the east of Antietam Creek, a stream that flows southward into the Potomac a few miles below Sharpsburg. Three bridges spanned the creek: the Rohrback Bridge (soon to become known as the Burnside Bridge and to play a crucial role in how the battle unfolded), the Middle Bridge, and the Upper Bridge. There were, however, several places where the water could be forded (although the Unionists seemed to have been oblivious to this reality).

McClellan intended to execute a double envelopment. But his plans were vague and his instructions unclear. Worse, he made some last-minute command changes, and he blurred the unity of command in one of his corps. What he wanted was for major thrusts to be made, both from above and below the Rebel position, with supporting attacks to create diversion along the entirety of the center. Actually, considering the terrain and McClellan's two-to-one numerical advantage (although *he* believed it was the other way around), the grand plan was a wise construct. The flaw was that Maj. Gen. Ambrose Burnside, who commanded the corps to the south, misunderstood his expected role: Burnside thought that his attack was secondary to, *not* surely (as it indeed was) an equal part of, the main.

As the daylong fight ensued, the Federals launched five successive but poorly coordinated assaults serially from north to south, and then stalemate ended the struggle. The defending Confederates were able to prevent a debacle only because

of the superb tactical management of Lee and his principal subordinates. But the Confederates suffered grave casualties throughout the day, because—save for the later-famous sunken farm road that provided a natural trench for some Southern defenders—they generally were unintrenched and were seriously outnumbered.

The opening assault commenced at 6:00 A.M. It drove the defenders quite slowly but nevertheless steadily rearward. Unexplainedly, however, Federal Maj. Gen. Edwin V. Sumner's corps was held back until 7:20. In the meantime, Rebel infantry, supported by forward batteries, stormed out of the west woods in powerful counterattack.

Burnside became pinned east of the Rohrback Bridge, and despite repeated attempts, his corps failed to storm the crossing. McClellan was late to learn of Burnside's predicament. Little Mac had wigwag flag communications with his two corps attacking from the north, but Burnside's men were obscured from direct view by those at the Federal headquarters, and the only communication was provided by couriers on horseback.

The Confederates found it practicable to diminish their forces facing Burnside and to redeploy them at more seriously threatened points. By midmorning the focus had shifted to the Rebel center. There, a farm lane, worn down by weather and long use, formed a natural trench. This the Confederates bolstered with a breastwork of fence rails. Later called by some the Sunken Road and by others Bloody Lane, this sector became the scene of the most awful slaughter: one Federal division lost 40 percent of its men; another, 30 percent. A Confederate officer wrote that his unit's first volley "brought down the enemy as grain falls before a reaper."

Suddenly, however, some mishap in Confederate command caused this position to be abandoned. Luckily for the hard-pressed Rebels, this was their only serious tactical error of the day. McClellan could have exploited his good fortune, because the position was clearly visible from his headquarters, but he did nothing, relying instead on the success he erroneously assumed Burnside would be achieving.

But Burnside's men were being battered. After they finally seized the bridgehead at about 1:00 P.M., they needed time to reorganize. Not until 3:00 P.M. could Burnside thrust strongly toward Sharpsburg. The Unionists almost smashed through, but suddenly, there came another dramatic turn of events. A new Confederate division, that of Maj. Gen. A. P. Hill, began arriving just in the nick of time—making "Up came Hill" an immortal Southern slogan.

Moving up on the road from Harpers Ferry, Hill's men surged into the hard-pressed lines, slashing into Burnside's

unguarded left flank. Scurrying back toward the bridge, Burnside's corps managed to retain its integrity and to assume a more potent defensive stance. The now thoroughly exhausted Confederates were too spent to drive Burnside any farther.

Nightfall at last brought the end of this, the single bloodiest day of the Civil War—indeed, the single bloodiest day in all of the American military experience. The South lost 13,724 to McClellan's 12,469, but another 12,500 Federals had been taken at Harpers Ferry. Photographers reached the Antietam battlefield before the dead were buried, and the horrifying pictures, widely distributed, shocked as well as entranced a jolted public. Both armies had been hurt tremendously, but neither had gained the critical advantage, and no further fighting seemed to offer rational promise. The battle dictated that the campaign now must end. Lee's army could no longer be supplied, and it was impossible for it to disperse and forage. There was nothing for the Southerners to do but to disengage and go back to Virginia.

The aftermath brought an end to McClellan's military career. Abraham Lincoln could neither understand why nor tolerate that no effective pursuit was made and no further destruction of Lee's army attempted. Early in November, seven weeks after the battle, McClellan was relieved of his command. Although the president was extremely disappointed, he nevertheless regarded the outcome of the battle to be a sufficient example of victory to justify—without his action seeming to reflect any tinge of desperation—for him to issue a preliminary proclamation of emancipation. The Union war aim was now refined and made more complex. Originally it had been the simple goal of restoring the union by force; now it was gradually—though inexorably—becoming also to destroy by force the institution of human slavery in the United States.

A very significant, and quite readable, biographical study of Lincoln is the prizewinning *Abraham Lincoln: Redeemer President* by Allen C. Guelzo (Grand Rapids, Mich.: William B. Eerdmans, 1999).

Antietam thus became a singularly major turning point in the war; had it turned out otherwise, the battle *might* have become to the Confederate States of America what Saratoga had been to the American States in 1778. But not only was this not to be, the fall of 1862 was destined to mark the moment when two major Southern thrusts onto Union soil were blunted and turned back, for there simultaneously had been an eventually to be stymied advance into Kentucky, and furthermore now—even though it still remained at this time an imperfectly formed one—*freedom,* not just union, became a Northern goal.

McClellan never internalized the reality of Antietam. Indeed, just as Andrew Jackson had ceremoniously relit a candle from his headquarters tent on the anniversary of the Battle of New Orleans, each year McClellan celebrated the anniversary of Antietam. "Those on whose judgment I rely," he had exulted, "tell me that I fought the battle splendidly and that it was a masterpiece of art." His family shared the attitude; his daughter, who later married a European and lived in France, named her home the Villa Antietam. But McClellan was to receive no more command assignments. When R. E. Lee was informed that the Young Napoleon had been removed, he remarked to James Longstreet, "I fear they may continue to make these changes 'till they find someone whom I don't understand."

The significance of the military cemetery at Antietam alone would have guaranteed that the site forever remain one of historical importance. Land was purchased, and the cemetery was incorporated by the state of Maryland. Delegates from several states that had soldiers at Antietam formed the Antietam Cemetery Association to oversee its development and to superintend it thereafter. (Incidentally, those who are interested in our military cemeteries in general should consult Dean W. Holt's *American Military Cemeteries: A Comprehensive Guide to the Hallowed Grounds of the United States, including Cemeteries Overseas* [Jefferson, N.C.: McFarland & Company, 1992].)

There are 4,687 internments at Antietam: 2,894 of the known and 1,793 unknown. The grave-plats are laid out by states, nineteen states being represented. One thousand four hundred seventy-five of these graves are filled by Antietam battle participants, who had originally been interred in hastily dug make-do grave sites nearby. The balance of the bodies in the cemetery were brought from the battlefields of Monocacy, South Mountain, Harpers Ferry, and other places. They, of course, are all Federal dead; the Confederates for the most part are buried in Hagerstown and Frederick, Maryland; Shepherdstown, West Virginia; and in local church and family cemetery lots.

The Battle of Antietam affected Americans of both North and South deeply and profoundly. Indeed, even while the Civil War still was raging on, the Antietam battlefield already had become an object of curiosity that attracted visitors. The wartime visitors even included some combatants: when on July 9, 1864, Confederate Generals Jubal Early and John C. Breckinridge were leading an incursion into Maryland, with the hope of slamming into Washington, D.C., they found time to visit the former battlefields around Sharpsburg.

In July 1877 the federal government took control of the cemetery at Antietam and soon thereafter unveiled the first marker: the Private Soldier Monument, locally known as Old Simon. The cemetery—as was typical for all of the early battlefield parks—proved to be the nucleus of the park-to-be.

Congress directed the War Department to take charge of the Antietam National Cemetery in 1870, and seven years later it appropriated monies to pay the indebtedness of the board of trustees. When on August 30, 1890, the place was established as a national battlefield site, and, thereafter, the War Department began its acquisition of major battlefields, Antietam entered into a phase of more rapidly progressive development. By 1894 there were roads and paths crossing some forty acres of the battlefield.

Later the state of Maryland and a number of local farmers ceded several minor tracts of land to the U.S. government, and soon state monument commissions began erecting memorials and markers. Interest in commemorating the battle site was, as usual, most intense among the veterans who had fought there. Success in keeping the number of monuments and memorials small was at first just happy accident; more recently it has been consciously decided to strictly limit any additions. There are barely more than one hundred of them,

and this makes Antietam—as a major Civil War commemorative site—unique. Some visitors feel that the absence of huge numbers of markers makes the battleground more pleasant to visit and easier to learn from.

In 1933, Antietam, along with the other War Department holdings, passed under the purview of the National Park Service, and in the years that followed, there was a conscious effort to return the battlefield landscape to its 1862 appearance and to restore or rebuild, as necessary, several of the major landmarks of the fighting. For example, although the renamed Burnside Bridge was still in use, it had deteriorated badly. So, relying on old photographs, park personnel oversaw its restoration. Many of the most historic of places have been preserved and marked. These include Bloody Lane, where hundreds fell dead or wounded, and the fords where soldiers might have crossed the creek. Scenic overlooks have been added. The Dunker Church, where nearby had occurred so very much fighting and bloodletting, was reconstructed during the Civil War centennial.

A new visitor center and well-appointed museum opened in 1963. Today, many volunteers dressed in authentic period clothing help to interpret the battle and its era. Annually, on the weekend nearest the anniversary of the battle, there are special services held to honor the dead of this engagement.

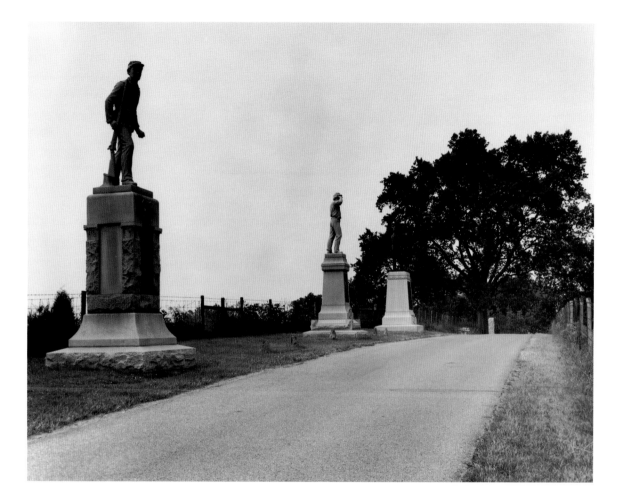

MONUMENTS
Row of Stone Men, Rodman Avenue.

MONUMENT
Col. Benjamin C. Christ, U.S.A.

122

Roulette Farm.

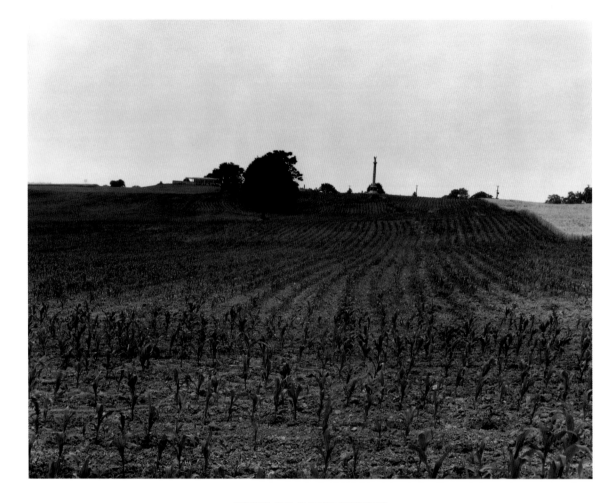

VIEW OF BATTLEFIELD
The Visitor's Center and the Maryland Monument.

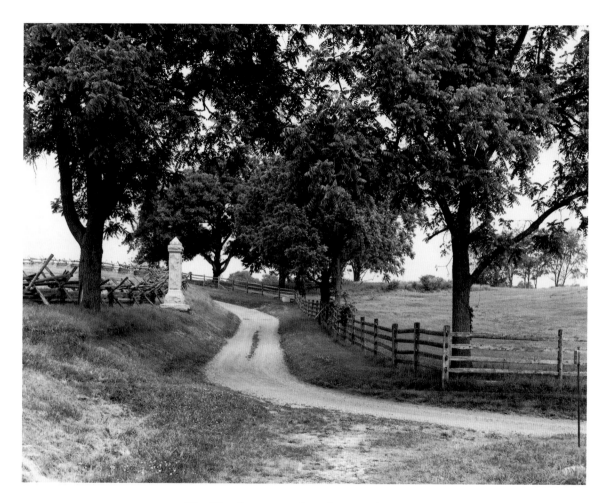

The Bloody Lane and Sunken Road (north).

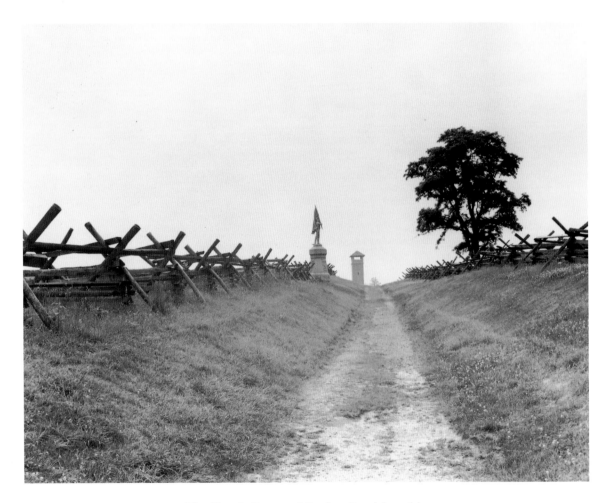

The Bloody Lane and Sunken Road (south).

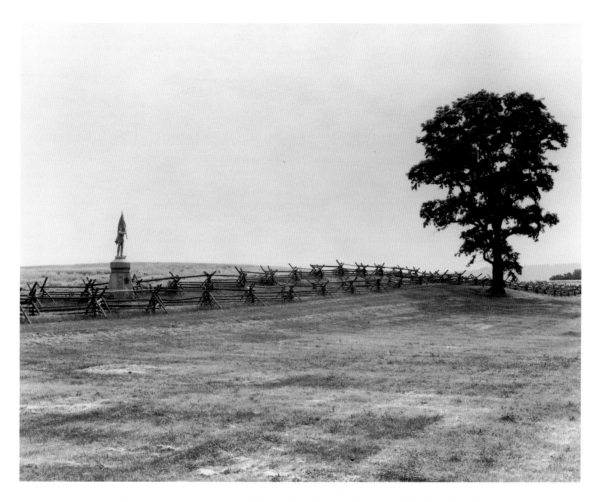

Infantry monument and Tree. The Bloody Lane and Sunken Road.

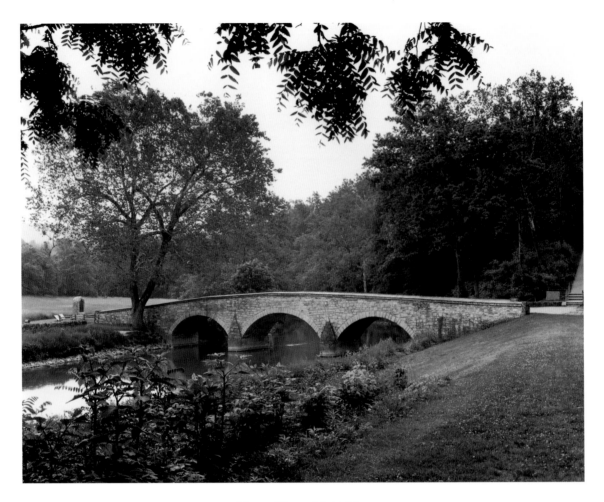

View of Burnside Bridge.

Burnside Bridge from Union Positions.

Broken Thistles.

V

Vicksburg

V

Vicksburg

ONTROL OF THE entire Mississippi River was a principal Union war aim from the very outset. By early 1862 the Union had seized all but a 110–mile stretch of the mighty waterway. At the endpoints of that, however, lay the strong points of Port Hudson, Louisiana, and Vicksburg, Mississippi. And these well-fortified and valuable positions the Confederates managed to hold on to tenaciously.

In late 1862 the Federals commenced an onslaught at both ends of the segment. On November 16 a Federal fleet steamed upriver from Baton Rouge, briefly bombarded the Port Hudson batteries, and then withdrew. For nearly a month thereafter things remained quiet, but on December 13 the Yankee fleet returned, and this time the pressure it exerted was much greater. The Northerners found, however, that Port Hudson was held by a determined garrison, and the place could not be easily taken. Indeed, Port Hudson would ultimately hold out against a siege, lasting even longer than Vicksburg, which would fall the following July. After that, continuing to hold Port Hudson was pointless, so it too capitulated.

Before the end of 1862, Grant launched the first of six attempts to force his way into Vicksburg. This time, however, he was unable to secure cooperation for the elaborate, three-pronged attack he had envisioned. N. P. Banks at Baton Rouge refused to take orders from Grant, and a raid at Holly Springs, Mississippi, destroyed Grant's supply base, making the northward overland thrust also impossible. Only a water-borne expedition under Maj. Gen. William T. Sherman would

be executed. This ended with the Battle of Chickasaw Bayou on December 29, 1862.

Sherman led 33,000 men in an attack against a "reorganized brigade" of 2,700 men commanded by the recently promoted Confederate Brig. Gen. Stephen D. Lee, plus another 2,700 Rebel defenders who served in and around Vicksburg. Lee was both lucky and efficient in directing his defense. The terrain provided a "funnel effect," which forced many Federal soldiers to bunch up into a killing zone. To cross a morass of mud and water, many Federals had to use a log bridge, which became a prime target for Lee's artillery.

The attackers managed to advance to within 150 yards of Lee's rifle pits, but then, as one of the attacking commanders put it, a withering "storm of shells, grape and canister, as well as minie-balls which swept the front like a hurricane of fire" shattered their ranks and forced the survivors to retreat. It was "a repetition of Balaklava," lamented one of the assaulting brigade commanders, Brig. Gen. John Milton Thayer, recalling a famous battle from the then-recent Crimean War distinguished by the hapless "Charge of the Light Brigade." "Although mine," Thayer continued, "was infantry and Earl Cardigan's force was cavalry."

The Federal casualties totaled 1,776 while the Confederates lost only 207. On December 31 a truce was arranged for the burial of the Union dead, and then Sherman reloaded his force onto the river transports, which steamed back to Memphis. Grant, however, was not a man who would let things lie; his men would be back, and his efforts would continue.

Jefferson Davis, at the same time, began to assert more influence on the situation in the western theater. He coldly assigned priorities, and he decided that holding Vicksburg and the stretch of the Mississippi River between there and Port Hudson was even more important than securing wider control in middle Tennessee. He therefore told Maj. Gen. Braxton Bragg to fight there if possible, but to fall back to the Tennessee River near Chattanooga if necessary, thus authorizing the potential abandonment of hundreds of square miles in a region from which the Confederacy desperately needed volunteers. But Davis believed that retaining the land linkages with the Trans-Mississippi was more vital.

On the other hand, at crucial moments, Davis seemed to waver. He received and rejected a proposal from Gen. Joseph E. Johnston that forces under generals John C. Pemberton and Theolophius Holmes should be ordered to cooperate in some vaguely envisioned joint operation. Davis did, however, order Bragg to dispatch a full division to Vicksburg. But, while Davis gave Bragg a direct order, he merely sent

suggestions to Holmes, leaving final decisions up to that general's judgment. One of Jefferson Davis's recent biographers, William C. Davis, insightfully suggests that President Davis was allowing himself to be hamstrung by his own military department system. The president could bring himself to order Bragg to reinforce Pemberton, because Bragg and Pemberton had been loosely combined in Albert Sidney Johnston's old Department of the West, but Holmes had not been a part of that.

Certainly President Davis tried to keep abreast of how things were going. He kept his aides very busy scurrying around the whole Confederacy visiting and checking on the various armies. Late in March he sent staff officers Preston Johnston to Tullahoma, Tennessee, and Joseph C. Ives to visit Pemberton at Vicksburg, then on to check things at Port Hudson. Davis certainly never intended that Pemberton should become bottled up at Vicksburg: "My purpose," Davis said, was, "an attack on Grant when in the interior, by combined forces of Johnston and Pemberton."

Though the reports concerning Johnston and his activities were less than encouraging, Davis chose to give this man, whom he much disliked, a lot of slack. Indeed, on the one hand, it is to Davis's great credit that he gave Johnston more patient response than he did any similar man in his lifetime.

But now Johnston had reached a point whereupon Davis *should* have lost forbearance for him. Alas, however, the only available alternative to Johnston in this important command was Beauregard—and Davis by now was doggedly resolute that Beauregard would never again have any important command. The historian and biographer William C. Davis suggests that this was President Davis's greatest mistake of 1863 and, indeed, quite possibly of the entire war.

President Davis's frustration was heightened by nagging illnesses. Once he was heard to cry out, in anguished pain, "If I could take one wing and [Robert E.] Lee the other, I think we could between us wrest a victory from those people." More than once did Davis daydream of taking an active command himself. Even more so did he ruminate on the Confederacy's scant supply of truly capable top-level generals. No doubt Davis had Johnston, Beauregard, and perhaps by now also Bragg and Pemberton in mind when he lamented to his brother Joseph, "A *General* in the full acceptation of the word is a rare product, scarcely more than one can be expected in a generation, but in this mighty war in which we're engaged there is need for half a dozen."

On February 2, 1863—demonstrating that it *could* be done—the Union ram *Queen of the West* ran past the Vicksburg

batteries. Until she was lost a dozen days later, this warship wreaked havoc upon both the Mississippi and Red Rivers; and her presence was a harbinger of what followed: Federal naval power proved vital to the ultimate success of Grant's campaign against Vicksburg.

Grant immediately set into motion a series of (ultimately four) schemes to force his way into the city. An unsuccessful attempt was made to deflect the waters of the Mississippi from the channel by digging what came to be known as "Grant's Canal"; Union gunboats tried haplessly to get into the Red River from above Vicksburg; an expedition was sent toward Yazoo Pass via a bayou but was blocked at Fort Pemberton; and a number of complex and fruitless maneuvers were conducted north of Vicksburg on Deer Creek, Steele's Bayou, and Rolling Fork. Grant later asserted that he had harbored only scant hopes that any of these schemes might work; instead he was saving his major effort for the spring and summer. That most likely was hindsight thinking; Grant was always serious about what he was doing at the time. But it was true that Grant's efforts stood a better chance of success after the Louisiana floodplain had dried sufficiently to allow overland marching of the army on the river's west side. Then Grant would have empty naval vessels, shielded by cotton bales, to run southward past the Vicksburg artillery batteries, while Grant and his troops marched overland to be picked up and ferried across the river.

In mid-April Grant managed to force things to a head. First, several diversionary thrusts were made: (1) Maj. Gen. Frederick Steele's division moved by water from Young's Point to Greenville, Mississippi, and then thrust inland on a marauding expedition; (2) Col. Benjamin H. Grierson led 1,000 cavalrymen on a raid from Grand Junction, Tennessee, to Baton Rouge (John Wayne in the movie *The Horse Soldiers* depicts this); (3) Sherman's corps made an elaborate feint from the north. Then, in the middle of the night on April 16, 1863, came the coup de grâce: Rear Admiral David D. Porter's fleet ran past the city. They met Grant at Hard Times, Louisiana, the place to which the troops had marched overland. The troops boarded the vessels and crossed the river.

Confederate defenders stymied the initial crossing attempt, but they could not stop Grant from moving rapidly to a position opposite Bruinsburg, Mississippi. There, outnumbering the defending Rebels by more than two to one, Grant forced the evacuation of Grand Gulf and then quickly took Port Gibson. There was a plucky Confederate resistance, which was aided by difficult terrain, but Grant prevailed.

By now the numbers of Confederate troops in Mississippi had been much bolstered by the concerned Rebel high com-

mand, which hurried reinforcements from wherever they could be found. Lt. Gen. John C. Pemberton soon possessed an army of some 32,000 men; and Gen. Joseph E. Johnston had another 6,000 near Jackson. Grant's field force numbered 41,000.

Grant moved with celerity, wanting to get between the two Confederate forces. He also wished to reduce the defenses of and secure the Mississippi State Capitol. On May 12 an engagement erupted at Raymond, Mississippi, fifteen miles from Jackson. During several hours of fighting, the two sides sustained about 500 casualties each, but the outnumbered Rebels were forced to withdraw rearward. Grant used one corps as a covering force to hold Pemberton's men at bay while the other two Federal corps moved to concentrate against Johnston. On the May 14, Johnston—outnumbered five to one—evacuated northward. In but brief fighting that afternoon, Grant easily seized the state capitol. Then, leaving minimal guards to protect against any sudden return by Johnston's men, Grant turned his main forces toward Vicksburg.

Pemberton's army stood between the Federals and the city. On May 16 Pemberton attempted to keep Grant from crossing the Big Black River by accepting what proved to be a major battle at Champion Hill. This elevation, a crescent-shaped ridge, is about seventy-five feet in elevation. The Confederate line stretched about three miles and eventually came to resemble the shape of the number seven. Pemberton expected the main Yankee attack to come along the vertical, but it actually came from the horizontal above. It was a bloody battle, described by one Union brigade commander as among "the most obstinate and murderous conflicts of the war." The Confederates, however, were outgeneraled and outmaneuvered, and finally they were finessed. Forced to withdraw, they proceeded grudgingly toward the Vicksburg defenses, fighting delaying actions as they went.

On May 18, 1863, the siege of Vicksburg began. As it progressed, Grant tried major assaults on May 19 and May 22, but the well-prepared fortifications held. Subsequently the Federals tried to tunnel under the defenses and blow them up. Grant also planned an assault for early in July—but that proved unnecessary, for a capitulation came.

On May 31, Davis wrote to R. E. Lee: "Gen'l Johnston did not, as you thought advisable, attack Grant promptly, and I fear the result is that which you anticipated." Davis confessed that he could not avoid entertaining reproachful thoughts, but "it would be unkind to annoy you" with them. As to Pemberton, the president said, "all accounts. . . fully sustain the good opinion heretofore entertained." How wrong Davis was: Pemberton was now two steps above his maximal level of

competence; this phenomenon was the great bane of the Confederate command structure, the Peter Principle in stark manifestation.

From fire belched by the gunboats on the river and from the constantly shooting troops in the encircling lines, the Vicksburg populace and their military defenders suffered onslaughts against nerve and will. The gunboats lobbed huge mortar shells, and some of the impact holes were as deep as seventeen feet. On the field, the situation was vividly described by Confederate Corp. Ephraim Anderson: "The enemy continued to prosecute the siege vigorously. From night to night and from day to day a series of works was presented. Secure and strong lines of fortifications appeared. Redoubts, manned by well-practiced sharpshooters, . . . parapets blazoning with artillery crowned every knoll and practicable elevation. . ., and oblique lines of entrenchments, finally running into parallels, enabled the untiring foe to work his way slowly but steadily forward." (Interested readers should check out Anderson's *Memoirs: Historical and Personal; Including the Campaigns of the First Missouri Brigade.* Notes and foreword by Edwin C. Bearss [Dayton, Ohio: Morningside Bookshop. 1972. First published in 1868].)

Large numbers of wounded men, some eight hundred or more in early June alone, suffered mightily in the Vicksburg hospitals—many of which were located in residences that had been converted for the purpose. The death rate was twenty, and sometimes even more, per day. In a moving letter to his wife, Chaplain William Lovelace Foster of the Thirty-fifth Mississippi Infantry described the horrors: "On passing through the hospital what a heart-rending spectacle greets the eye? Here we see the horrors of dreadful war! . . . The weather is excessively hot and the flies swarm around the wounded—more numerous where the wound is severest. In a few days the wounded begin to be offensive and horrid. . . . Nor can this be avoided unless a nurse were detailed for every man—but there is only one allowed for every eight men. . . . Never before did I have such an idea of the cruelty and the barbarism of war."

As the city trembled from the bombardments, the people therein gradually reduced their daily meals to one-half and then to one-quarter rations. Soldiers were obliged to eat mule meat, rats, and young shoots of cane. One of the entrapped civilians later recalled that her servant found rats dressed and for sale in the market. A Confederate enlisted man wrote that rat, when fried, had a flavor "fully equal to that of squirrels." One Missouri soldier stoutly held that "if you did not know it, you could hardly tell the difference, when cooked," between mule meat and beef.

Not only food, but even adequate drinking water, for some, became scarce. Here, however, we see an example of less-than-noble qualities displayed by some of the citizenry—a disinclination to share one's resources. Dore Miller, wife of a Vicksburg lawyer, had a private supply of fresh water, even while many other persons suffered from thirst. She wrote, "we hear of others dipping up the water from ditches and mud-holes. This place [her "bomb proof"—which was the name that civilians gave to the many caves in the area] has two large underground cisterns of good cool water, and every night in my subterranean dressing room a tub of cold water is the nerve-calmer that sends me to sleep."

At last, after forty-seven days of siege, Pemberton and all but two of his officers voted in a council of war that they should surrender on July 4, 1863. The Federals losses amounted to 4,910 during the siege, and the Confederates had suffered casualties amounting to 1,872 before they capitulated. The captives numbered 2,166 officers, 27,230 enlisted men, and 115 civilians in army employ. All were paroled, save for one Confederate officer and 708 men, who preferred to go north as prisoners. The Rebel army also yielded its entire complement of equipage: 172 cannons, large amounts of every ammunition type, and some 60,000 shoulder weapons.

Davis blamed Johnston; Pemberton the president saw largely as an innocent victim. The chief of ordnance, Josiah Gorgas, commented to Davis that Vicksburg had fallen from want of food. "Yes," replied Davis, "from want of provisions inside, and a general [Johnston] outside who wouldn't fight."

There soon followed a bitter personal loss for the president, and for that, too, he ultimately blamed Johnston. The president's brother Joseph had moved the family possessions, including all of Jefferson Davis's books, papers, and home furnishings, into, it was hoped, safe places. But a slave revealed the hiding places, and for two days hundreds of Yankee soldiers rummaged and plundered, carrying boxes out into the yard, breaking them open and scattering the contents to the winds.

The carpets from Brierfield (Davis's plantation) were cut into pieces as souvenirs and for saddle blankets, the draperies were hauled into various blue-clads' tents. The men took special delight in appropriating Davis's walking sticks and in drinking his wine. One small portrait of Davis was stabbed with knives again and again until it had disintegrated. For months afterward, various of Davis's personal letters were published as curiosities in Northern newspapers, and stories were rife about others of them being read publicly for entertainment of the enemy.

Davis still clung to his belief that Pemberton had made a keen sacrifice by his coming South (for he was of Northern birth), and—although nearly everyone was now condemnatory toward Pemberton—Davis said, "I can imagine nothing more unjust and ungenerous." While Pemberton would soon resign his lieutenant generalcy, he later returned to uniform and selflessly served the Confederacy thereafter in the rank of colonel. Nonetheless, and especially in the first weeks and months following the fall of Vicksburg, the populace vilified Pemberton as a pariah.

Also, criticism was soon turned on Davis for the loss of so dear a city. Davis, unlike the general public, perceived that the real failure was the result of flaws in certain of his top generals: he wrote later, "My confidence in General Johnston's fitness for separate command was now destroyed." But the president failed to sense the depth of public attitudes, let alone effectively try to mold them. One War Department official probably was correct in his suspicion that Johnston now had "more real popularity in the country than the President has."

The town of Vicksburg did not grow economically after the war, and to this day it remains a charming small Mississippi river town with little commercial significance. The Vicksburg National Military Park is the major attraction, along with several well-maintained and antebellum homes that are open to the public. The embittered populace did not again celebrate the Fourth of July until patriotic fervor during World War II changed their hearts and induced them to recant their long-held abstinence.

The news that Vicksburg had capitulated sparked jubilation all over the North, all the more so when, just a few days later, Port Hudson capitulated. Taking that place had cost nearly 10,000 Union men—dead, wounded, or physically impaired from disease or exposure—compared with the Southern losses of only 871. Now, however, as President Abraham Lincoln gratefully proclaimed, "The Father of Waters again flows unvexed to the sea."

The fall of Vicksburg was a major turning point in the war. This was even more effectively true because the Battle of Gettysburg had concluded just the day before the city capitulated. These two events had tremendous psychological impact upon the Southern populace. The venerable Professor James A. Rawley has observed that there was no parallel to what Grant had achieved in taking Vicksburg: "not Lee in the Gettysburg campaign, nor [Stonewall] Jackson in the Valley campaign, nor McClellan in the Peninsula campaign." (Highly recommended, incidently, is Rawley's *Turning Points of the Civil War* [Lincoln: University of Nebraska Press, 1966. New Bison Books

edition, 1989]). In retrospect, the Vicksburg siege was Grant's greatest strategic achievement, and in comparison it outshone even the best performances of Robert E. Lee. Indeed, it probably *was Vicksburg* (and not the later triumph at Missionary Ridge) that set the die for Grant's later elevation to lieutenant general.

Michael Ballard is working on what probably will be, when published, the finest one-volume history of the Vicksburg campaign. Meanwhile, perhaps the best way to begin study is with his *Pemberton* (Jackson: University Press of Mississippi, 1991), a fine biography that does justice to "the pariah of the Confederacy," the Northerner who ill-served the South's cause; and with volume one of Brooks Simpson's biography of U. S. Grant, *Triumph over Adversity, 1823-1865* (Boston: Houghton Mifflin, 2000).

Vicksburg was the fifth National Military Park to be established. The 1890s were a ripe decade for that kind of thing: Shiloh Park had been created in 1892, Gettysburg (as a National Military) Park in 1895, and Vicksburg chartered in 1899. Former Confederate Lt. Gen. Stephen D. Lee, who had been in command at the Battle of Chickasaw Bayou, and was a brigade commander during the campaign and siege, was instrumental in securing national authorization for both Shiloh Park and Vicksburg Park. He served as vice president of the Shiloh Battlefield Association. But because of his personal experiences at Vicksburg, he was much more intensely interested in, and involved with, various preservation efforts there.

Of course, other persons also had some passion for seeing to the establishment of a military park at Vicksburg. A Union captain from Dubuque, Iowa, John F. Merry, took the initiative on October 23, 1895, to organize the Vicksburg National Military Park Association. This group elected a slate of officers, and it chose S. D. Lee as its president. The officers selected influential persons from all over the country to serve on the board of directors. At once they commenced various activities all aimed at helping to carry out their purpose. The executive committee ordered that a map of the Vicksburg area be prepared, and it drafted for submission to Congress a bill that would create a military park. The committee also secured options on part of the land to be purchased, at an average price of thirty-five dollars per acre. The bill, introduced in the House of Representatives on January 20, 1896, underwent a long period of consideration and reconsideration, but finally it passed, on February 21, 1899.

Even before the bill's final passage, S. D. Lee had begun maneuvering to secure a place for himself on the park commission—and this was quite a precedent for a former

Rebel officer! He wanted it for a number of reasons, among them genuine interest and concern. In early February 1899 he wrote to several influential senators asking for their support. Meanwhile, one of his friends circulated a petition among the senators urging that they join in supporting his candidacy, and about thirty of them signed recommendations for him. (Lee had become nationally prominent, as president of Mississippi A&M College—later Mississippi State University. He had been offered a brigadier generalcy in the U.S. Army during the Spanish-American War and been considered as a possible Democratic vice presidential nominee.) One of Lee's supporters, the famous "Pitchfork Ben," Benjamin Ryan Tillman, wrote him, "I hope you will get the position as I know of no one half so worthy to fill it."

Lee's campaign for the job was successful. He became one of the three initial park commissioners. The others were Union veterans: Capt. William T. Rigby and Capt. James G. Everest. They held their first meeting on March 1, 1899, in Washington, D.C., and elected Lee their chairman. "I got the place all right," Lee wrote to a friend, "a better place than I thought it was and duties apparently light."

One wonders what Lee meant by "light," for he worked long and hard on park business. He wrote literally *thousands* of official letters (many of which are reposed in the park headquarters, available to researchers by special arrangement) and made numerous long trips, speaking before groups, organizations, and the legislatures of every southern state. In trying to generate interest in the park and raise funds for construction of the monuments, Lee presented an impressive figure: "Lion of battles, and knightly gentleman of the olden time," wrote one newspaperman, Lee "makes an appeal . . . which can scarcely be denied."

On March 15, 1899, the commissioners established an office in Vicksburg and there commenced work immediately. Rigby set up residence in the city (Lee lived in Columbus, Mississippi) and served as the chief functionary; the others kept in touch through frequent letters and visits. The first task was to secure contracts for land purchases. Human nature being what it is, that brought the committee's first major problem: some of the landowners had grossly exaggerated ideas of the value of their property. The committee achieved some success with reasoned persuasion, but it also deemed that it might initiate condemnation proceedings against some of the more unreasonable property owners. When confronted with this threat, most of the people holding out for more money capitulated and accepted a fair appraisal price. Acquisition then

proceeded rapidly, and by the end of September 1899, the commission had secured approximately 910 acres.

The park commission encountered some major problems and many more minor ones. Lee desired that the park acquire a reference library and managed to secure many donations of books. The commission also wished to purchase 250 copies of parts one, two, and three of volume fourteen of *War of the Rebellion: Official Records of the Union and Confederate Armies*—that part which pertains to the Vicksburg siege—for distribution to the various state commissions and to interested groups. Initially Secretary of War Alger balked at the expenditure for this, but he ultimately yielded to the commission's urging. The subsequent replacement of Alger by an even more frugal individual, Elihu Root, together with the commission's growing desire for still-larger appropriations and for additional land purchases, precipitated a much more difficult situation.

When Root attempted to curb the commission's expenditures below the amount originally authorized by Congress, Lee suggested that the commission should appeal directly to Congress. Rigby persuaded Lee to accept a more moderate response, but thereafter relations between Root and Lee were strained. Lee took a clever tack in future requests for land

purchases, by indicating to Root that most of the existing acquisitions were areas where the Confederates had maintained positions, and he implied that proper commemoration of the United States troops would suffer if funds remained too short. Root mildly slapped Lee's hand for having purchased any land at all without specific prior approval from the War Department, saying that "the criterion for past purchases, though perhaps not unreasonable, is not in accord with the present views of this Department." Sufficient monies were secured, however, so that the park now has over 1,300 acres, but the development spread out over many succeeding years.

From the first Lee was determined that the park should be authentic and complete in every possible detail. In instances where the topography had changed since 1863, he insisted that maps and pictures be prepared to show it exactly as it had been. He journeyed to other military parks, such as Chickamauga-Chattanooga, Gettysburg, and Antietam, to study their good points. "What kind of a park are we to have," he asked when the commission encountered difficulties, "one of dignity and quality like Gettysburg and Chickamauga-Chattanooga, or a cheap park which will not satisfy the American people." Lee liked *lots* of monuments, which Vicksburg eventually got—there are 1,324 in the park, and there is a

tremendous amount of symbolism in many of them. He did not like Antietam, because of its comparatively scanty number of monuments (though some viewers believe that a park like Antietam offers a better view of what the battle actually was like as it unfolded).

As at many other battlefield parks, Massachusetts was the first to dedicate a memorial—this one near the site of Grant's headquarters. The pedestal, a granite boulder, proved so heavy that ten yoke of oxen were needed to transport it. Three years later Illinois outdid that by emplacing a moment Romanesque monument that bears the names of all 36,000 Illinois soldiers who participated in any of the operations against Vicksburg. This monument includes the name of Pvt. Albert J. D. Cashier, who actually was a woman really named Jennie Hodgers. (A true and permanent transvestite, after the war she kept her sex a secret until 1911, when it was discovered by a physician attending to a broken leg she had suffered in an automobile accident. In old age she collected an invalid soldier's pension and was very active in the Grand Army of the Republic. She died in 1915 and was buried in uniform with full military honors.) A fine new book on women of the Civil War armies is *All the Daring of the Soldier* by Elizabeth D. Leonard (New York: W. W. Norton, 1999). And utterly delightful reading, as

well as quaintly informative, is *An Uncommon Soldier: The Civil War Letters of Sarah Rosetta Wakeman, alias Pvt. Lyons Wakeman, 153rd Regiment, New York Volunteers,* edited by Lauren Cook Burgess (New York: Oxford University Press, 1994).

The commission ran into considerable trouble with its work. "The Secretary wants to know, why a continuous roadway? Why so many bridges? I consider them . . . most essential . . . ," Lee asserted. "I believe we should not yield what we consider essential."

Also, the initial authorization from Congress did not allow for the purchase of any guns for the park. So Lee early began urging that the War Department donate guns from stocks of no-longer-used weapons. And Lee wanted the water batteries to be restored, a project for which there was no money. He argued persuasively, contending that the United States Navy had served a key role in the Vicksburg campaign—even U.S. Grant had said so, Lee pointed out—and the sailors should receive their share of honor and recognition. But years of difficult negotiations went by before these goals could be accomplished, though they ultimately were—to the enormous credit of the park.

For several reasons, these difficulties being among them, Lee meanwhile resigned the chairmanship of the commission. Rigby previously had taken over on several occasions and was

functioning as full time de facto chairman throughout 1901. On April 15, 1902, Lee formally resigned the post, and Rigby succeeded him. Although no longer chairman, Lee remained a dedicated member of the commission until his death in 1908.

Some of the troubles that had motivated Lee to resign the chairmanship continued for a lengthy period after he stepped down. The most vexing one was the War Department's parsimony and the war secretary's persisting tendency to demand that the commission revise its plans along more economical lines. The secretary found an ally—a real thorn in the commissioners' sides—in the initial park engineer, E. E. Betts, and in his successor, his brother R. D. Betts, who took the post on September 29, 1899. The brothers Betts recommended less roadway footage and cheaper bridges for the park, exactly what the war secretary wanted to hear. The commission also had trouble with the Betts brothers over surveying and mapping the park.

The secretary of war seemed continually to overrule the commission's desires in favor of the Betts's recommendations. "It is mortifying indeed," Lee exasperatedly wrote in October 1901, "to have carefully matured plans ignored, and turned down." The commissioners regarded R. D. Betts as a "young smart aleck" and a "crafty fellow," and Lee wrote that "it is a pity that the Secretary cannot see that he is being deceived . . .

by Mr. Betts." At first Lee suspected "that there is someone behind the scenes, who is belittling our park and its work," and he decided to try pulling strings in Congress. He wrote to Missouri Senator Francis Marion Cockrell, with whom he had served in the Army of Tennessee, asking for intervention. But the scheme backfired; and in May 1902, Lee wrote that "it is evident to me now, we are being punished, and our work retarded, because we have worked over the head of the Secretary, using political influence." There was nothing left to do but continue with an earlier conclusion to "pocket our mortification, and do the best we can in carrying out the views of the Secretary—we are now virtually relieved of responsibility of the policy of development."

Actually the situation was not so gloomy as Lee and the other commissioners thought, but their work did drag out over a longer period than would have been required with larger appropriations and more cooperation from the War Department. In the long run, the commission's seemingly extravagant approach proved to have been the best and most economical means to accomplish what finally was done in the park. Meanwhile, as the commission's work gradually progressed, internal problems developed.

Lee and Rigby engaged in bitter disagreement over several matters. One concerned the texts of the commentaries to be

placed upon the various historical markers. Lee insisted upon strict adherence to the official records, except where interpolation seemed clearly to be called for. Specifically, he took pains to see that "justice" was done to the Confederate side; to him this meant showing that the Federals greatly outnumbered the Southern forces. Rigby at times was willing to interpolate, but rarely was he in agreement with Lee on the matter of numbers. Both men were stubborn. The last straw for Lee came when Rigby discredited Pemberton's troop returns for March 31, 1863. "I am the more convinced . . . that we will not be able to get together on our points of divergence," Lee wrote, and "I have therefore about decided to submit the facts where we differ to higher authority." At last they reached a workable compromise, Rigby taking the advice of the park historian, John S. Kountz, and putting fewer words on some of the tablets and changing some of the others. In the end Lee disapproved on only a few of the tablets, though even that scant number angered and distressed him considerably.

Another major controversy concerned the park's guns. Rigby asked the War Department for fewer guns than Lee thought justified. "The other parks got all the guns they wanted," contended Lee, "and ours from the very nature of a siege and defence requires a large number to illustrate the conditions." "We will get more," he continued, "I will certainly press this matter." But they did not get more; they got only 128. Then Lee and Rigby began a long feud over where the guns should be placed. Rigby wanted to divide the guns about equally between Union and Confederate emplacements; Lee insisted upon the exact same ratio as had been the case in 1863 (236 Union to 102 Confederate). Rigby argued that "the Confederate line will always be the line of greatest interest in the park," but Lee countered that "you are looking more to pleasing appearances on the Confederate line, than to showing the actual facts and relative values of the two sides." Once again, while Lee did not entirely get his way, there was a compromise worked out.

In spite of their hard fights with each other, the commissioners actually were warm friends. Rigby once received a letter from Kountz, the park historian, referring to Lee as one "whom we all love" and another letter from Everest saying, "what a noble soul he is." And in 1903 Lee wrote to Rigby that "my contact with you has inspired me with such faith in your accurate work, that I am almost ready to accept anything you present."

Lee's work at Vicksburg symbolized an effort to preserve the past and to promote harmony among the sections, so that all might enjoy the reunited country's glorious future, as well as

revere its near-sacred past. He could not have been more satisfied that his last public appearance was a speech in the park, before the survivors of Union Gen. Michael K. Lawler's brigade. On that occasion too, Rigby informed Lee that a statue of him would be erected in the park. "Rigby, you are all mighty sweet to me," the former Rebel general exclaimed. Lee looked out over the surroundings, and he admired "the tough physical surroundings—high hills and deep valleys" (which add to the picturesque appearance); it was his deeply held conviction that Vicksburg was "the greatest of the parks."

Additions to the park continued from time to time. When the United States was about to enter World War I, in 1917, the state of Missouri—which had been bitterly divided and had sent many men to fight on either side—perhaps captured the spirit of national unity by dedicating a memorial at Vicksburg to her men in both armies.

In the ensuing years there were roads created or improved; several streets that ran from the city through the park closed, and a new sixteen-mile tour route was prepared. A new visitor center was built near the old Baldwin's Ferry Road, one of the avenues of escape cut off to the Confederates in 1863.

A particularly special feature was added to this battlefield park with the recovery and display of the USS *Cairo*. In 1956 this Union ironclad, which had sunk in 1862 to the muddy bottom of the Yazoo River, was found. Eight years later parts of it were raised, and in 1973 the National Park Service took over ownership of the vessel. She now stands near the former channel of the Mississippi River, close to the National Cemetery. A partial restoration of the vessel was completed in 1984. Not only does she make this park quite unique, her presence is a fitting memorial to the United States Navy—which was of quintessential significance in cooperating with the army and bringing Union victory in the decisive western theater.

Avid readers may be interested in Herman Hattaway's *General Stephen D. Lee* (Jackson: University of Mississippi Press, 1976) and in an article by Terry Winschel, the national park historian at Vicksburg, "Stephen D. Lee and the Making of an American Shrine," in the *Journal of Mississippi History*.

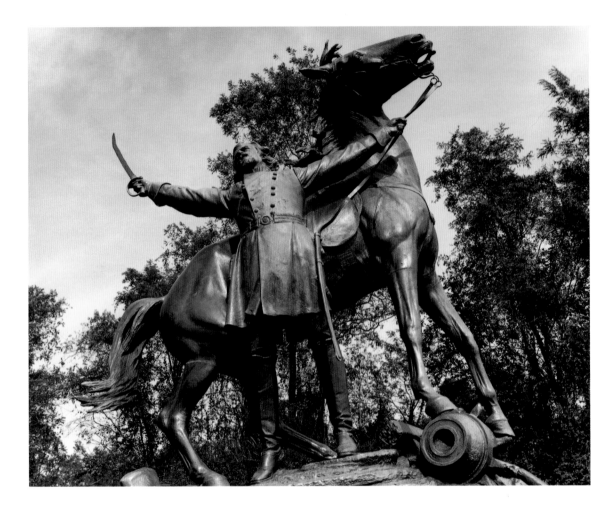

MONUMENT
Gen. Lloyd Tilghman, C.S.A.

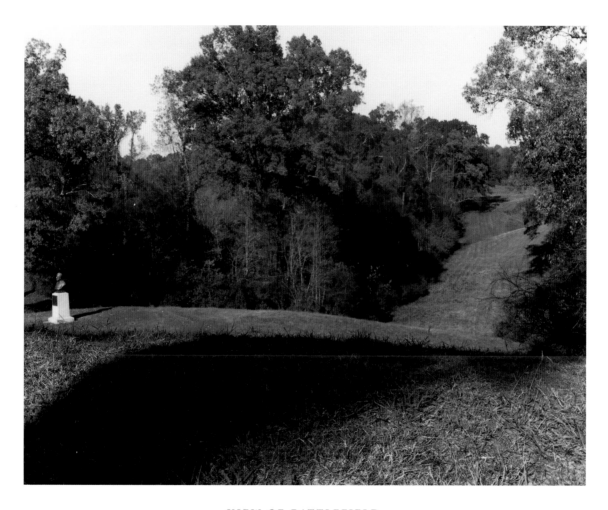

VIEW OF BATTLEFIELD
Union Lines.

Vicksburg Court House.

Thayer's Approach, Union Protective Tunnel (north).

Thayer's Approach, Union Protective Tunnel (south).

Confederate Heights, Overlooking Thayer's Approach.

CANNON DISPLAY
Confederate Lines, Navy Monument.

Trees and Vines along Union Avenue.

MONUMENTS
Jackson Road.

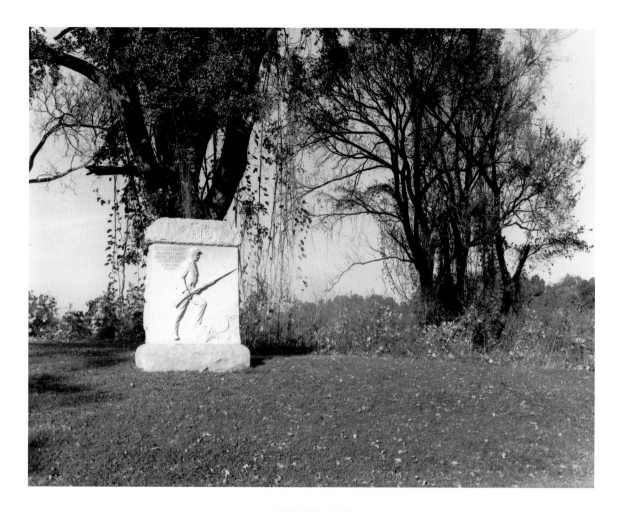

MONUMENT
Sixty-eighth Ohio Infantry.

MONUMENT
Woods and Illinois Memorial.

Thicket and Monument.

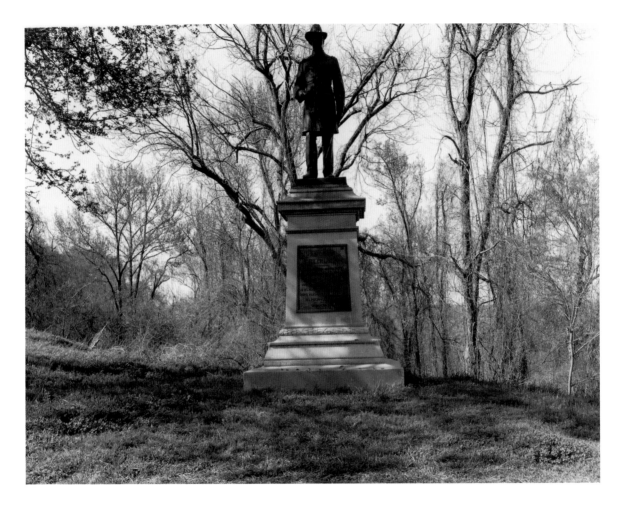

MONUMENT
Maj. Gen. John A. Logan.

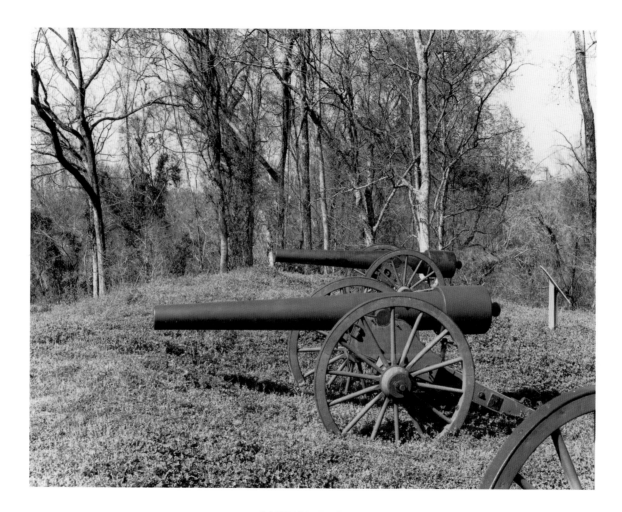

CANNON DISPLAY
Near Illinois Memorial.

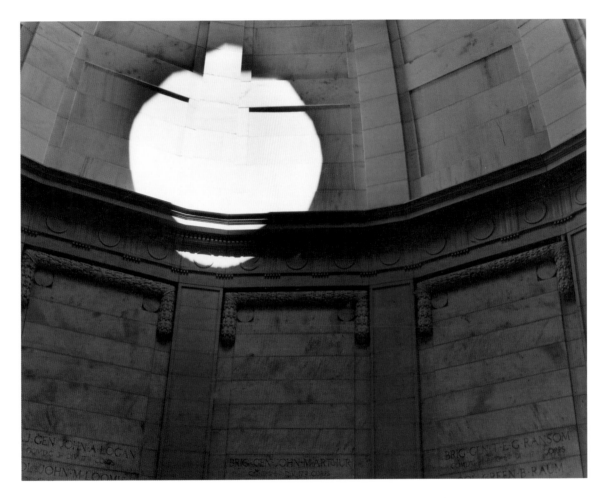

Interior of Illinois Memorial.

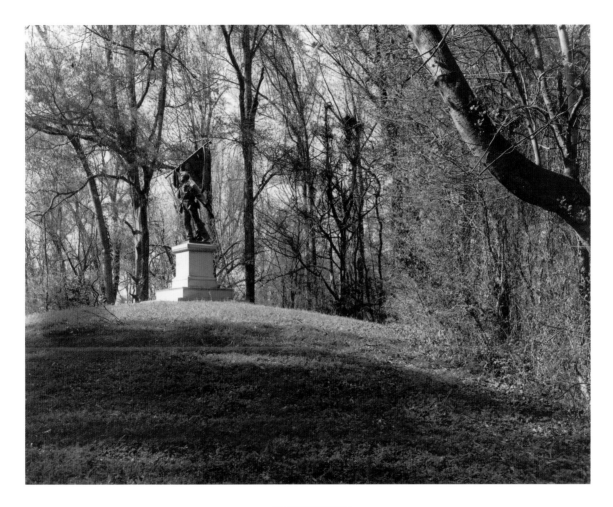

MONUMENT
Rhode Island Seventh Infantry.

MONUMENT
Gen. Nathan Kimball, U.S.A.

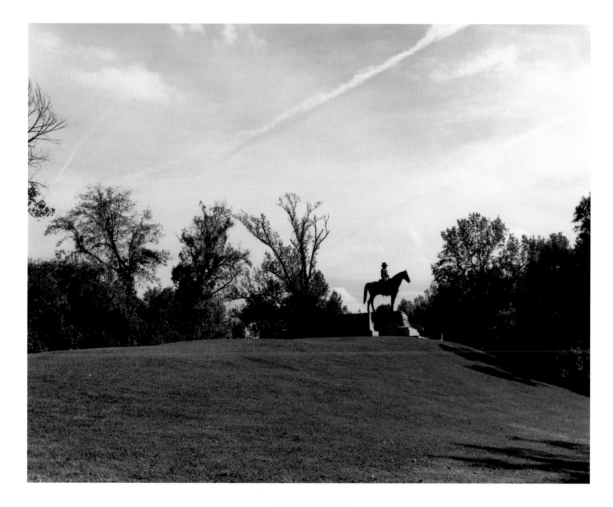

MONUMENT
Maj. Gen. U. S. Grant.

Thickets and Underbrush: a Strange Place.

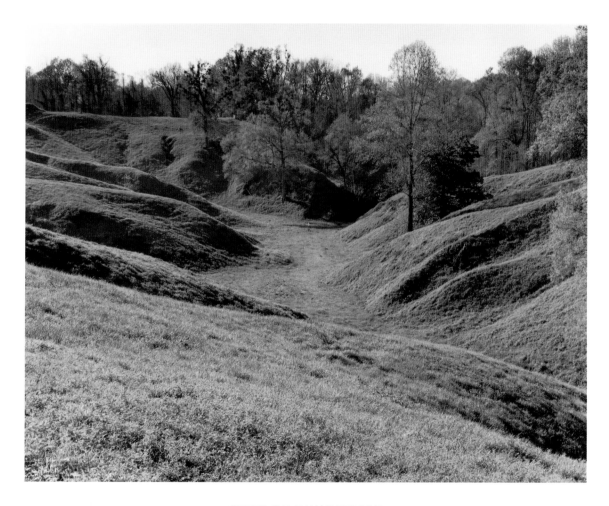

VIEW OF BATTLEFIELD
Old Graveyard Road.

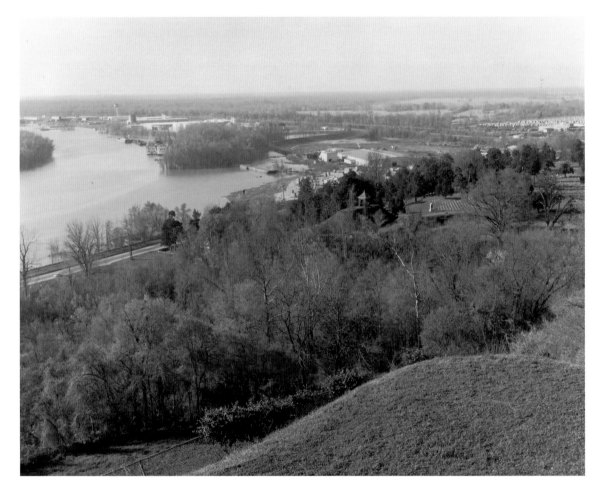

View of Mississippi River from Fort Hill.

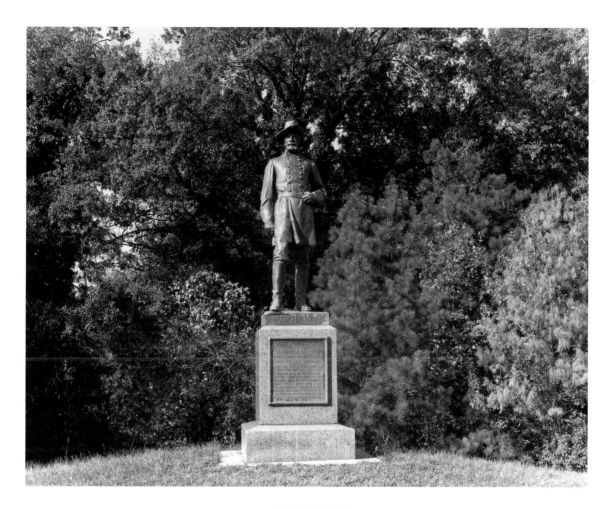

MONUMENT
Gen. John C. Pemberton, C.S.A.

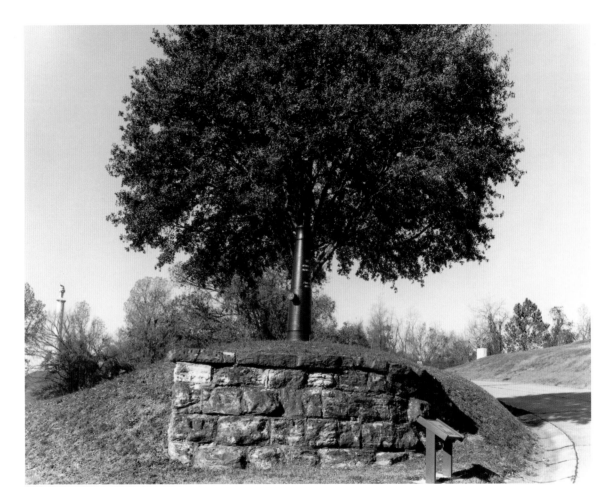

Cannon and Tree, Site of Vicksburg Surrender.

Illinois Central Gulf Railroad.

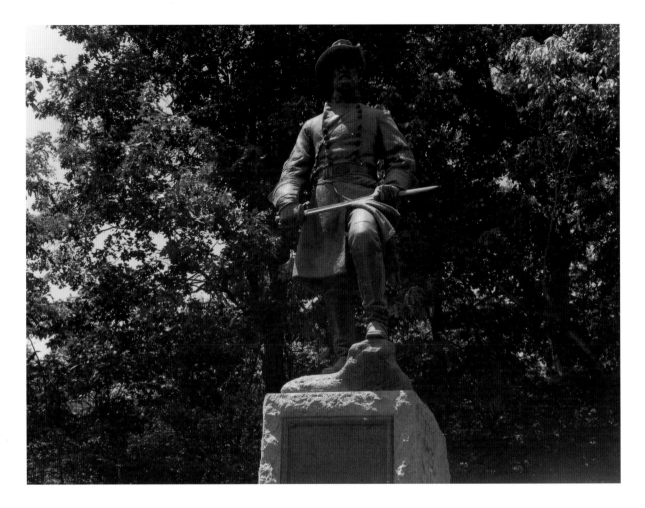

MONUMENT
Gen. Stephen D. Lee.

MONUMENT
Brig. Gen. Edward D. Tracy, C.S.A.

MONUMENT
Brig. Gen. Isham Garrott, C.S.A.

MONUMENT
Gen. H. T. Walker, C.S.A.

Tree Trunk at Vicksburg National Cemetery.

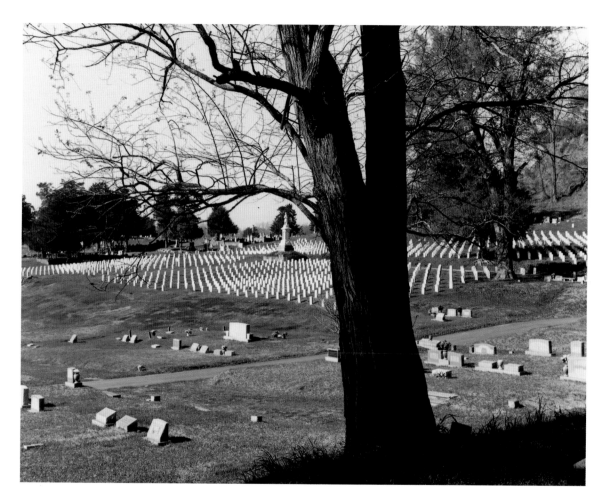

Tree Overlooking Vicksburg City Cemetery.

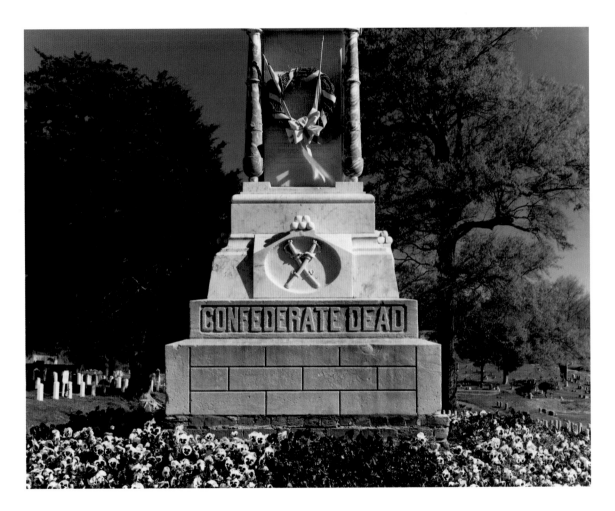

MONUMENT
Confederate Dead Memorial, Detail, Vicksburg City Cemetery.

EPILOGUE

THE PARKS REMAIN, and interest in them endures. The countless thousands of visitors to them every year gain starkly variant enjoyments and lessons from the time spent therein. Seeing any of the battlefield parks is a touching, perhaps even a soul-searing, experience. We think that the monuments and memorials, their artistic appeal and profound significance, add much and are always well worth taking some time to see, savor, and enjoy.

From them, we draw inspiration, and we feel that they well hallow the memory of the courageous soldiers who fought—and so many of whom died or were maimed—in the Civil War: the "bright crimson gash" that divides all of American history.

ABOUT THE PHOTOGRAPHS

Gettysburg

West (First Day of Battle)

Page 15 The seminary's tower was used as an observation post, first by the Federals and then by the Confederates. It overlooks much of the battlefield.

Page 16 Burns, a veteran of the War of 1812, worked as a cobbler at Gettysburg. Incensed at the Confederate invasion of his country, he joined the Union army. He was wounded three times fighting with the Iron Brigade during the war and was decorated by President Lincoln in 1863. He died in 1872.

Page 17 A tree trunk was often considered a symbol of death in the nineteenth century. This tree holds a pack and other items an infantryman might have carried. The monument stands where the unit fought on the first day of battle northwest of Gettysburg.

Page 18 On July 1, 1863, Reynolds, commanding the vanguard First, Second, and Eleventh Corps of the Army of the Potomac, reached Gettysburg midmorning. He quickly brought in his infantry to replace his cavalry, who were outgunned by the Confederates. He was killed by a Confederate sharpshooter on the first day of fighting.

Page 20 Culp's Hill became the tip of the "fishhook" Union line at Gettysburg. Strategically important, it protected Cemetery Hill and Cemetery Ridge.

Page 21 The Thirteenth New Jersey was on the line and played a major role in repulsing Pickett's Charge. While a diversion, the attack on Culp's Hill proved important to the outcome of the Battle of Gettysburg.

Page 24 This cannon display is located on the high ground in Devil's Den. The guns point toward the location of the Confederate lines. Little Round Top and various monuments may be seen in the back-

ground. Devil's Den is remembered as the location of a bloody battle that took place on the second day of fighting at Gettysburg. The Confederates took the ground, and held it until the larger battle was lost.

Page 25 Colonels included Henry D. Terry, Samuel E. Beach, and John Pulford. Battles fought included Manassas, Fredericksburg, Chancellorsville, Gettysburg, Wilderness, and Cold Harbor. At Gettysburg the unit was on the left flank of "Sickles' Salient" and lost 109 officers and men.

Page 26 Now shrouded in shade from a surrounding forest, in 1864 the spot was open to light. O'Sullivan, with the help of an assistant, placed the corpse of a Confederate soldier in the hollow and recorded for history a complete fabrication.

Page 27 Ellis was a civil engineer who worked in railroads and mining. His regiment captured five battle flags in a bayonet charge.

Little Round Top

Page 28 Colonels included John S. McCalmont, James T. Kirk, and Adoniram J. Warner. Battles fought included Mechanicsville, Antietam, Fredericksburg, Gettysburg, and Wilderness. After Fredericksburg the unit stood down for a year, recovering from heavy losses. It was mustered out the summer of 1864.

Page 29 Colonels included John McLane and Strong Vincent, who were both killed in action. Battles fought included Gettysburg, Cold Harbor, and Petersburg. Only one Federal regiment sustained more casualties.

Page 30 Joshua L. Chamberlain, newly appointed colonel to the Twentieth Maine, received orders to hold a small wooded hill on the extreme left of the Union line located on Little Round Top. His men repulsed repeated Confederate attacks. As Longstreet's Alabamians prepared for one final attack, Chamberlain realized his men had nearly exhausted their ammunition. Refusing to surrender, he led a bayonet charge that flanked the Confederates. He thus held the vital position. He was awarded the Medal of Honor thirty years later.

Page 31 Colonels included Richard Franchot, Emory Upton, and Egbert Olcott. Battles fought included Fredericksburg, Wilderness, Petersburg, and Cold Harbor. Considered one of the finest officers of the war, Col. Emory Upton gained fame at Spotsylvania. The unit captured four flags at Rappahannock Station.

Page 32 A tranquil morning in Gettysburg. Adjacent to Devil's Den, the lowlands below Little Round Top were the site of terrible fighting on the second day of the battle.

Page 33 Crawford joined the army as an assistant surgeon and commanded a battery of artillery during the attack on Fort Sumter. His unit suffered 50 percent casualties at Cedar Mountain. He was wounded at Antietam. He fought gallantly at Gettysburg, Wilderness, Spotsylvania, and Petersburg, and by the war's end he had been promoted to the rank of brigadier general.

Page 34 Often considered foreign, Irish regiments frequently sustained high casualties. It was common for units to be recruited by ethnic group, and all the soldiers from one town might be in the same regiment.

Peach Orchard and Other Battlefield Sites

Page 35 Maj. Gen. Daniel E. Sickles abandoned his position on Cemetery Ridge and moved his troops to what he considered the high ground near the Confederate line. Sickles's controversial move unhinged the Union left, created an area of vulnerability, and threatened the army's position.

Page 36 A clenched fist remains defiant. The monument faces Seminary Ridge, where Confederate troops massed for attack.

Page 38 Monuments located here honor the cavalryman's devotion to his horse.

Confederate Lines: Seminary Ridge

Page 41 On July 2 the Confederates, under the command of Gen. Robert E. Lee, were convinced that they could break the Union line. They attacked, concentrating their efforts on a copse of trees, the only landmark visible through the smoke from firing cannon and rifles. The Union devastated the Confederate soldiers led by Maj. Gen. George Pickett; there were 15,000 Rebel casualties.

Cemetery Ridge and the Union Center

Page 43 Having been routed, the remnants of two Union corps spilled onto Cemetery Hill late in the afternoon on the first day of fighting. Maj. Gen. Winfield Hancock restored order and prepared a defensive position. The hill anchored the northern end of Cemetery Ridge, the center of the Union line. The Confederates attacked at twilight, but were repulsed, and the Union still held the ground the next day.

Page 44 Chaplain of the Irish Brigade gives last rites to soldiers before they go into battle.

Page 45 Along this route the defeated Confederate soldiers limped back to their lines.

Page 46 It was here that the Union line was breached temporarily, but the Rebel soldiers had been exhausted by the struggle. Federal reserves were brought up, and the Confederates were quickly captured or killed.

Page 47 The most sacred site at Gettysburg. It was toward this copse of trees that Lee directed his attack because it could be clearly seen by troops charging the Union line.

Page 48 Although the moment portrayed here never happened, Lewis Armistead, brigadier general, C.S.A., and Winfield Scott Hancock, brigadier general, U.S.A., were friends and Masonic brothers before the war. Armistead died from wounds received in Pickett's Charge; Hancock survived the war.

Chickamauga-Chattanooga-Missionary Ridge

Page 69 The Wilder Brigade of Indiana was honored with a monument. The brigade was commanded by Lt. Col. John Thomas Wilder, who insisted that his troops be armed with Spencer repeating rifles. Chickamauga was one of the first places where Union troops used their own non–army-issue repeating rifles. One Confederate commander heard so many shots he overestimated the number of troops defending the line.

Page 71 A daylong battle was fought in clearings and dense woods.

Page 74 This site was named for the Kelly house; in the first day's fighting here, neither side gained a decisive advantage.

Shiloh

Page 101 Johnston was a graduate of West Point and one of the South's most promising warriors. He was a man of strong physique, standing over six feet tall, and commanding presence. He died at Shiloh when a minié ball nicked an artery, causing him to bleed to death before he realized he was in mortal danger. His loss was a catastrophe for the South.

Page 102 A tree stump, white from the weather, marks the site where Johnston was mortally wounded.

Page 103 On April 6, the pond offered comfort to soldiers on both sides as they drank the water or used it to wash their wounds. Many died there. The sight of men half-submerged in the pond, dead horses and battle debris strewn about, and the water turned red by blood had a profound effect on anyone who witnessed the scene.

Page 107 Union Brig. Gen. Benjamin M. Prentiss's division rallied along a sunken road in a densely wooded thicket. The Confederates repeatedly charged across a wide field, trying to dislodge the Union forces. All attempts failed until sixty-two cannon were brought to bear on the thicket; the resulting barrage overwhelmed the Federals. Prentiss, who knew his division could endure no more, surrendered his force of two thousand men in the late afternoon. The site was dubbed the "Hornets' Nest," and the name stuck.

Page 108 Gen. Daniel Ruggles, C.S.A., turned his guns on the Hornets' Nest with devastating effect. Shiloh proved to be the high point in his military career. After the battle he found himself shuffled through a series of administrative positions in the army's rear guard. His career rallied when he was appointed commander of eastern Louisiana, but he was replaced six months later. He was finally appointed head of the Confederate prison system in the last month of the war.

Page 110 Grant crossed the river at Pittsburg Landing.

Antietam

Page 121 Union army lines organized here for their final attack on Confederate troops.

Page 122 Monument honoring Colonel Christ and the Fiftieth Pennsylvania Volunteer Infantry.

Page 126 For four hours Union and Confederate forces contested this sunken road, which became known as "Bloody Lane." The conflict produced over five thousand casualties. At first the road offered cover for Confederate soldiers repulsing a Union attack, but later it trapped them as Union forces poured into positions that offered a clear shot down the lane. Dying men fell atop one another, forming heaps of bodies on the roadbed.

Page 128 The bridge is named for Gen. Ambrose Everett Burnside. His easygoing attitude was considered too loose for a commanding officer, and he liked to gamble, which resulted in poor judgment. His delayed action at Antietam and stubborn determination to cross the bridge

over Antietam Creek cost him dearly. His troops were slowed down crossing the bridge and were fired upon by Alabamians dug in above the bridge. The troops eventually crossed a mile downstream but were too late to crush the rapidly retreating Confederates.

Vicksburg

Page 148 Tilghman attended West Point and graduated forty-sixth in the class of 1836. Formerly commander of Fort Henry, he was taken prisoner and was exchanged in the fall of 1862. He fought at Corinth, Vicksburg, and at Champion Hill, where he was killed while directing artillery fire.

Page 149 Looking west along Union Avenue near the Minnesota Monument.

Page 150 A museum today, the court house was an important landmark that could be seen from the river.

Pages 151, 152 The Confederate army held a fortresslike hill from which sharpshooters could pick off advancing Union soldiers. Maj. Gen. John Milton Thayer ordered tunnels built to protect his men from Confederate fire. Miraculously, a handful of Union soldiers made it to the top of the hill, but they were quickly killed or captured.

Page 154 Dense overgrowth and a cannon overlook deep ravines. The South favored smoothbore cannon. Although they had a shorter range than the Union's cannon, they were lighter and easier to maneuver in long marches. They were available, cheap, and could be loaded with canister and used as large shotguns at short range against an advancing foe.

Page 155 Dense underbrush now covers the Union lines.

Page 162 The memorial is modeled after the Pantheon in Rome. Its open roof allows a circle of light to play across the list of heroes' names inscribed on its walls.

Page 164 Kimball attended what is now DePauw University and taught school at Independence, Missouri. He studied medicine under the supervision of his brother-in-law, a local physician. He lost a command at Antietam but later regained it. He was wounded at Marye's Heights at Fredericksburg. After recovering he led a corps at Vicksburg.

Page 165 Grant had failed in business but proved to be the Union's most successful and relentless general. He was victorious at Vicksburg and was promoted to general in chief after his victory at Chattanooga. He accepted Lee's surrender at Appomattox on April 9, 1865.

Page 167 The Yankees' failure to overrun this fortification was a major reason for Grant's decision to avoid further direct assaults on Vicksburg.

Page 168 Since 1864 the river has changed course, leaving only a marshy rivulet today. This formidable fortress was never challenged other than by naval bombardment.

Page 169 A Northerner by birth, Pemberton entered West Point in 1833 and displayed a deep love for the South, advocating southern political ideals and befriending with southern cadets. He married a woman from Virginia, thus strengthening his ties to the South. He joined the Confederate army while his two brothers remained loyal to the Union. The defender of Vicksburg, he finally surrendered to U. S. Grant on July 4,

1863. Because he was originally from the North, he was highly criticized for the loss of Vicksburg and suspected of treason by Southern legislators. He accepted a demotion to colonel of artillery and never regained his previous status.

Page 170 Beneath this tree, Gen. John C. Pemberton surrendered his army of twenty-nine thousand to Grant on July 4, 1963.

Page 172 Lee graduated from West Point in 1854. He fought at Vicksburg, Champion Hill, and, after a prisoner exchange, in the Atlanta Campaign. Wounded on the retreat from Nashville, he returned to duty during the final Carolinas Campaign and surrendered in 1865. After the war he was active in the United Confederate Veterans, promoted women's rights, worked for the preservation of the Vicksburg battlefield sites, and became a historian.

Page 173 Tracy began his Civil War service as a captain of the Fourth Alabama. He fought at Shiloh, where his horse was shot out from under him. In 1862 he was promoted to brigadier general. At Port Gibson he was shot through the heart and fell without uttering a sound.

Page 174 Garrott helped form the Twentieth Alabama and was appointed its colonel. He took command of Brig. Gen. Edward D. Tracy's brigade after Tracy's death. Bored with duty in the besieged city of Vicksburg, Colonel Garrott borrowed a soldier's rifle and took a place on the skirmish line; he was killed by a Union sharpshooter while inspecting an outpost. His promotion to brigadier general arrived several days later.

Page 175 Walker, the son of a U.S. Senator, entered West Point at age sixteen. He became one of Georgia's most esteemed soldiers. He was wounded in the Seminole War and in the Mexican War. As a major, he was an instructor of tactics at West Point from 1854 to 1856, but resigned his commission to enter the Confederate army; he was promoted to brigadier general a short time later. He served under Gen. Joseph Johnston in the Army of Tennessee in the Mississippi Campaign, fought gallantly at Chickamauga, and was killed in battle defending Atlanta from Sherman's troops in 1864.

Page 176 Vicksburg contains three old cemeteries. One is the National Cemetery, where Union soldiers were buried. When it was discovered that Confederate soldiers had been mistakenly buried there, the Confederate dead were taken to the city cemetery, located a few miles from the battlefield. Located within the military park is a Jewish cemetery of the site of fighting. This cemetery is often mistaken for the Vicksburg City Cemetery.

Page 177 Most of the defenders of Vicksburg are buried here, soldiers and civilians alike. The cemetery is divided into graves of officers, those of enlisted men, and those of civilians.

INDEX